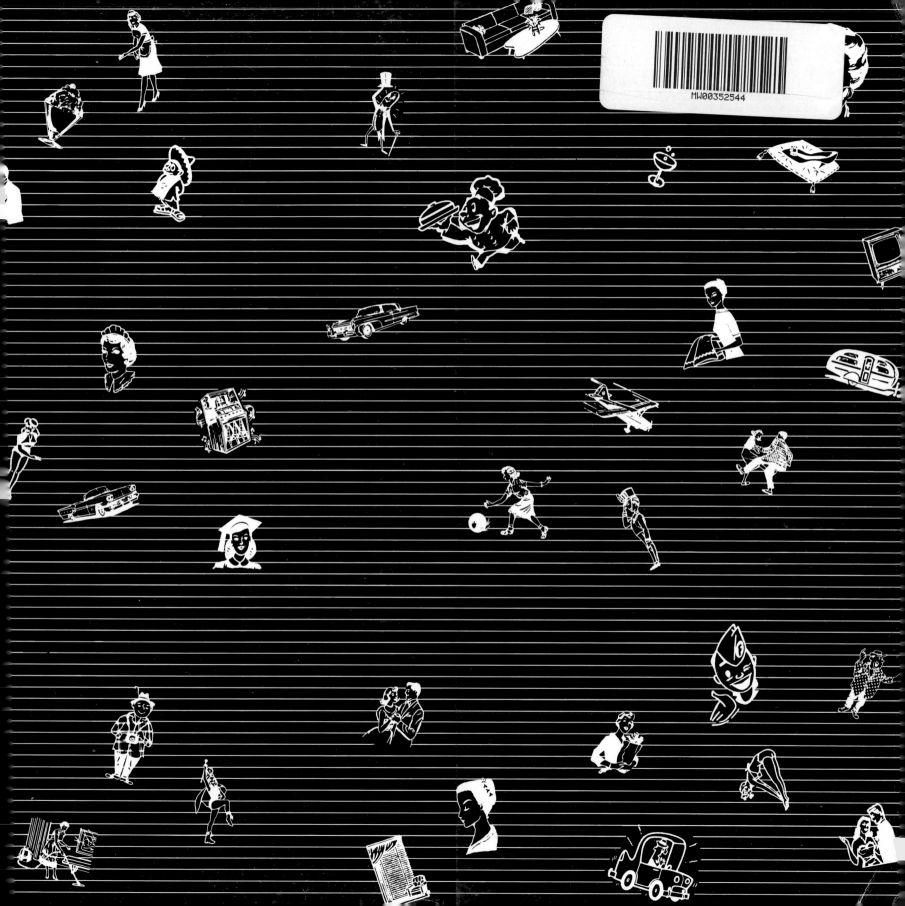

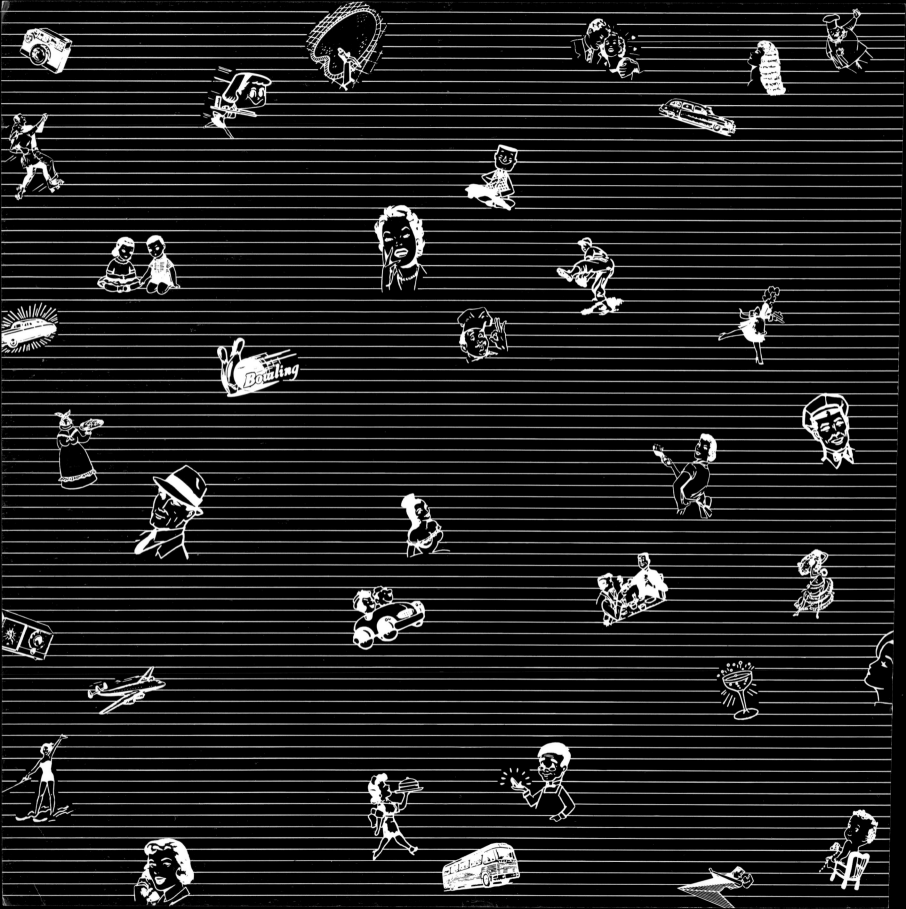

MATCHBOOK ART

Yosh Kashiwabara

Chronicle Books • San Francisco

First published in the United States 1990 by Chronicle Books

First published in Japan by Libro Port Publishing Co., Ltd.

Printed in Japan.

Library of Congress Cataloging in Publication Data

Kashiwabara, Yosh.
 [Paper match collection]
 Matchbook art / by Yosh Kashiwabara.
 p. cm.
 Reprint. Originally published: Paper match
 collection Tokyo
 Japan : Libro Port Publishing Co., 1989.
 ISBN 0-87701-732-8 (pbk.)
 1. Matchbox labels—United States. I. Title.
NC1890.U6K37 1990
741.6'94'09730904—dc20 89-25467
 CIP

Distributed in Canada by
Raincoast Books
112 East Third Avenue
Vancouver, B.C.
V5T 1C8

10 9 8 7 6 5 4 3 2 1

Chronicle Books
275 Fifth Street
San Francisco, California 94103

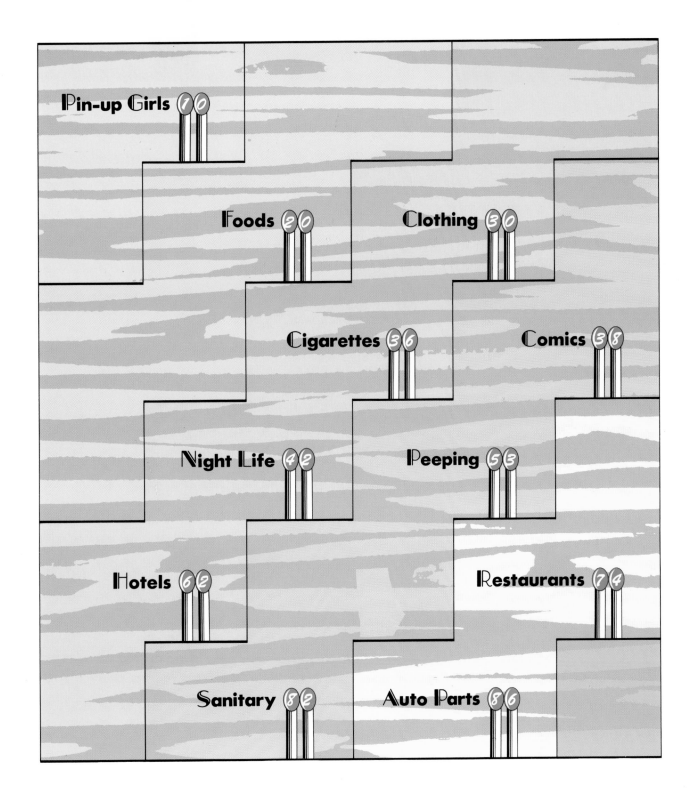

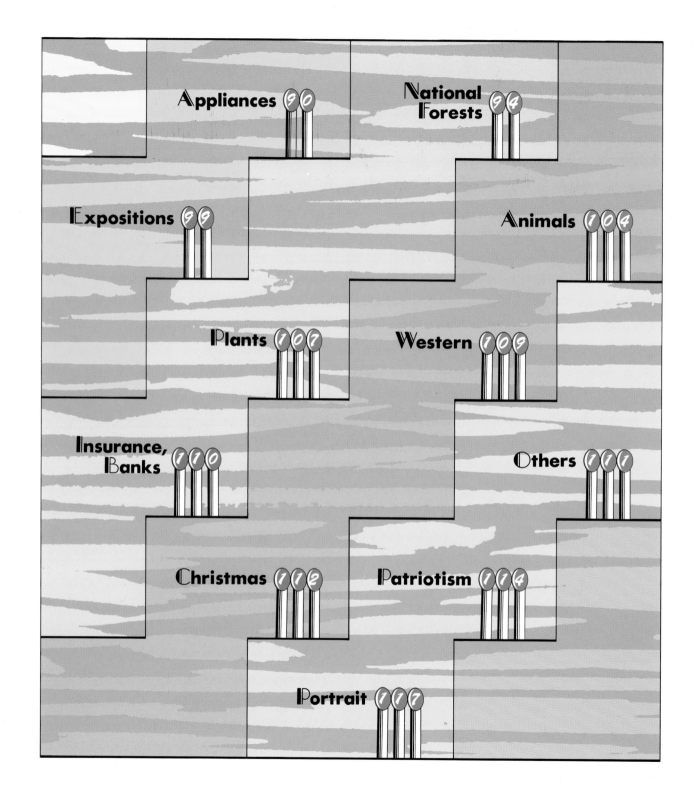

INTRODUCTION

In 1957—a golden year in a golden era for American consumers—my family moved to Los Angeles from Japan. The overwhelming abundance of products and advertising was a shock to me. I had never imagined such a world, where there were so many things to buy and where "keeping up with the Joneses" was so important. It seemed that American consumers worked hard so that when one of their neighbors bought a new product, they could buy one too. New products kept appearing—televisions, washing machines, and refrigerators—and consumers kept buying.

Throughout the century, in fact, as more and more new items flooded the market, manufacturers competed fiercely to win buyers. Advertisements large and small became more eye-catching; bright, cheerful ads were reproduced on billboards and in magazines, but companies were still searching for more and better venues for their ads. Then somebody had a great idea—why not put ads on matchbooks? Matchbooks permeated all areas of society and offered a perfect surface for shorthand advertising messages.

In the 1950s, smoking in restaurants was more widespread than today. Waitresses carried matches to light their customers' cigarettes, and it was from a flirtatious waitress in a coffee shop that I received the first

matchbook in my collection. Before I knew it, I was collecting match-books as part of my daily routine. Matchbooks represented the culture in condensed form; they were handy collectibles that were free and easy to acquire. Soon, I expanded the scope of my collection and began to acquire vintage matchbooks.

When you look at the collection in its entirety, these engaging miniatures reveal the distinctive characteristics of their era. From food and fashion to national parks and restaurants, matchbooks distill the trends and dreams of decades past. All together, the colorful images evoke memo-ries and nostalgia for a bygone period of American culture.

YOSH KASHIWABARA

MATCHBOOK ART

Pin-up **G**irls

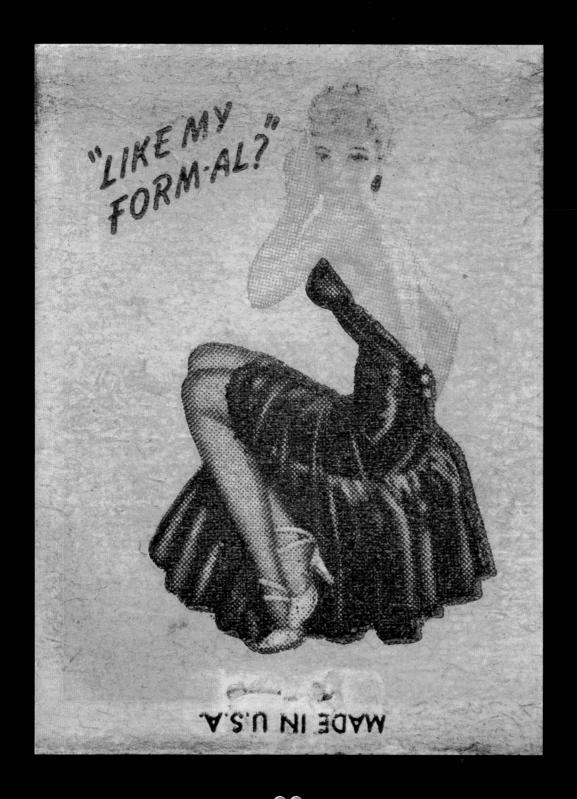

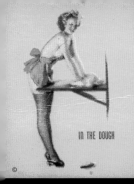
IN THE DOUGH

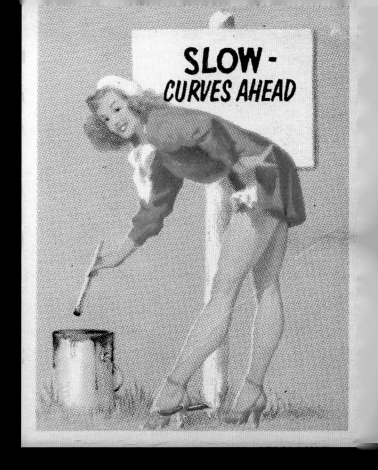
SLOW - CURVES AHEAD

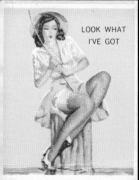
LOOK WHAT I'VE GOT

MONTREAL, QUE.

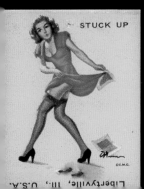
STUCK UP

Libertyville, Ill., U.S.A.

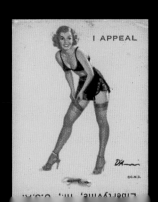
I APPEAL

Libertyville, Ill., U.S.A.

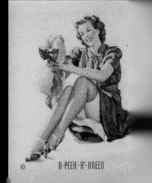
A PEEK-A-KNEES

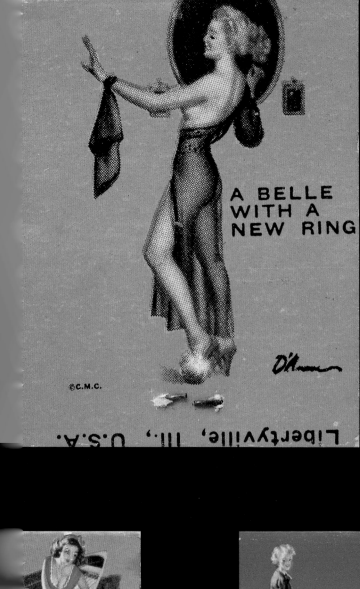

A BELLE
WITH A
NEW RING

©C.M.C.

Libertyville, Ill., U.S.A.

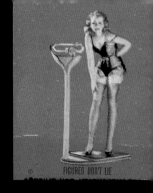

FIGURES DON'T LIE

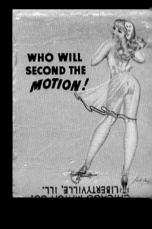

WHO WILL
SECOND THE
MOTION!

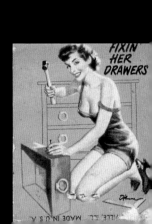

FIXIN'
HER
DRAWERS

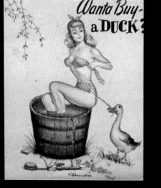

Wanta Buy a DUCK?

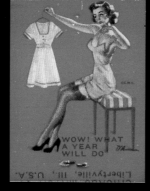

WOW! WHAT A YEAR WILL DO

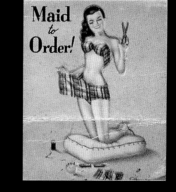

Maid to Order!

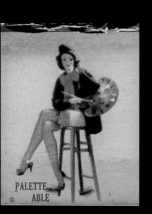

PALETTE ABLE

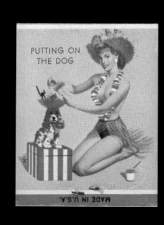

PUTTING ON THE DOG

MADE IN U.S.A.

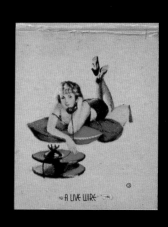

A LIVE WIRE

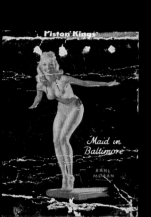

Piston Kings

Maid in Baltimore

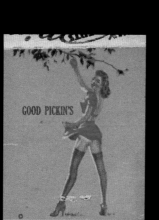

GOOD PICKIN'S

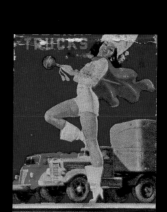

TRUCKS

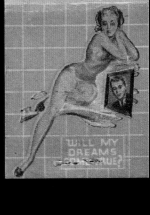

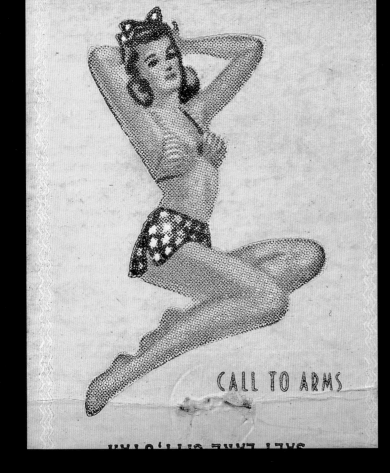

CALL TO ARMS

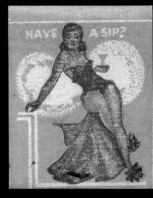

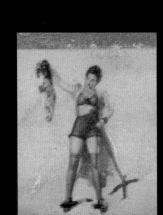

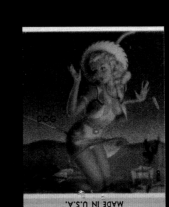

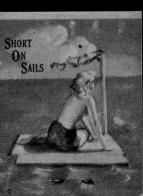

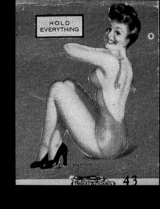

A GOOD TIE-UP

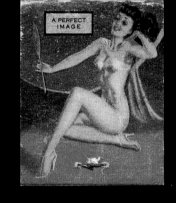

A PERFECT IMAGE

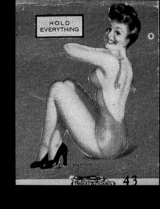

HOLD EVERYTHING

43

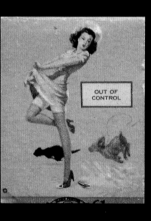

OUT OF CONTROL

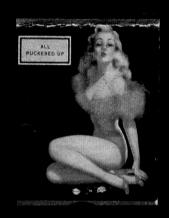

ALL PUCKERED UP

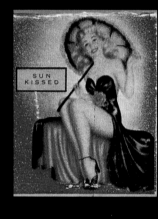

SUN KISSED

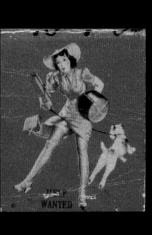

HELP WANTED

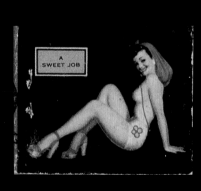

A SWEET JOB

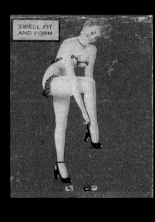

SWELL FIT AND FORM

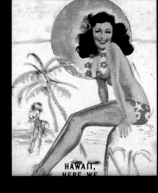

HAWAII,
HERE WE

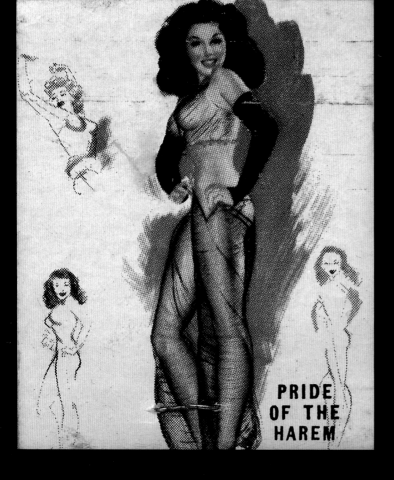

PRIDE
OF THE
HAREM

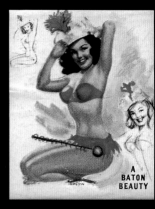

A
BATON
BEAUTY

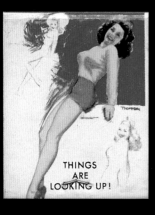

THINGS
ARE
LOOKING UP!

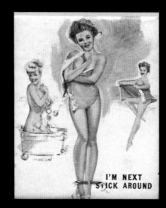

I'M NEXT
STICK AROUND

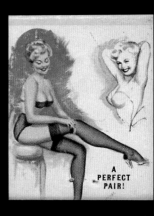

A
PERFECT
PAIR!

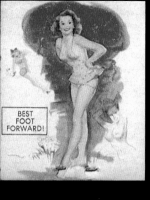

BEST FOOT FORWARD!

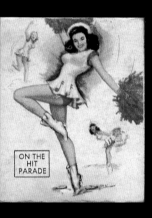

ON THE HIT PARADE

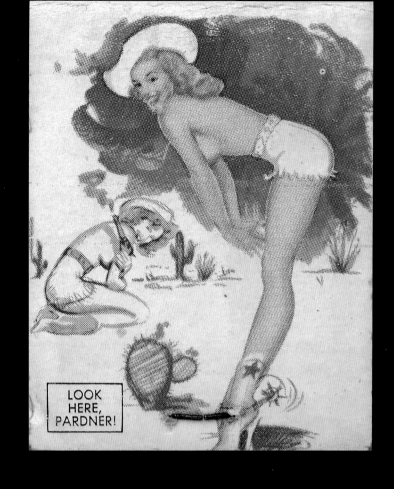

LOOK HERE, PARDNER!

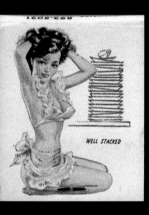

WELL STACKED

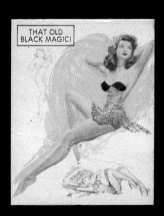

THAT OLD BLACK MAGIC!

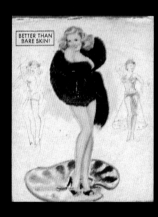

BETTER THAN BARE SKIN!

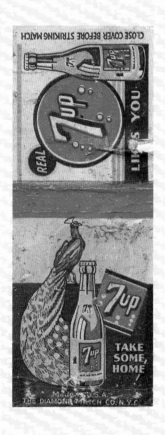

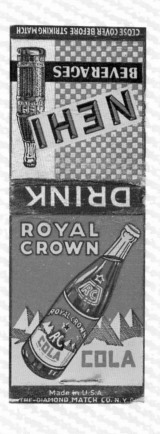

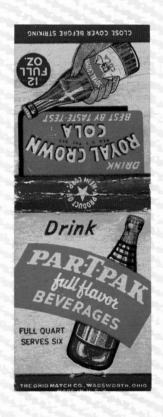

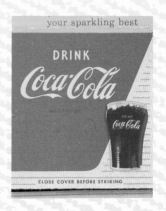

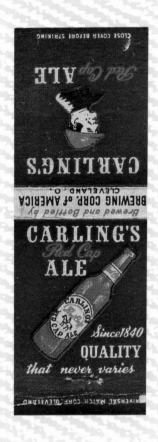

Red Cap ALE

CARLING'S

Brewed and Bottled by
BREWING CORP. of AMERICA
CLEVELAND, O.

CARLING'S
Red Cap
ALE

Since 1840

QUALITY
that never varies

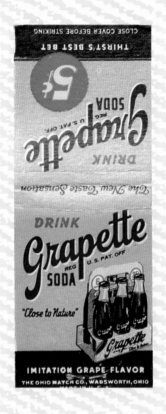

THIRST'S BEST BET

5¢

Grapette
SODA
REG U.S. PAT. OFF

DRINK

The New Taste Sensation

DRINK

Grapette
REG U.S. PAT. OFF
SODA

"Close to Nature"

IMITATION GRAPE FLAVOR

THE OHIO MATCH CO., WADSWORTH, OHIO

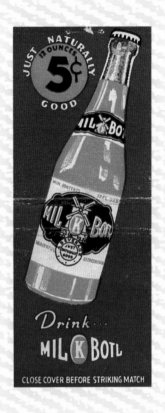

JUST NATURALLY GOOD

12 OUNCES

5¢

MIL K BOTL

MIL K BOTL

Drink...

MIL K BOTL

CLOSE COVER BEFORE STRIKING MATCH

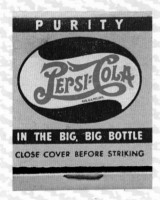

PURITY

Pepsi-Cola

IN THE BIG, BIG BOTTLE

CLOSE COVER BEFORE STRIKING

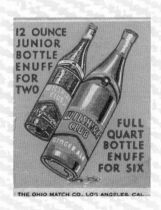

12 OUNCE
JUNIOR
BOTTLE
ENUFF
FOR
TWO

WILSHIRE
CLUB

FULL
QUART
BOTTLE
ENUFF
FOR SIX

THE OHIO MATCH CO., LOS ANGELES, CAL.

When Cold and Crisp

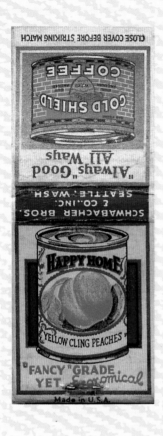

CLOSE COVER BEFORE STRIKING MATCH

COFFEE

GOLD SHIELD

"Always" Good
All Ways

SCHWABACHER BROS.
& CO., INC.
SEATTLE, WASH.

HAPPY HOME

YELLOW CLING PEACHES

"FANCY" GRADE
YET Economical

Made in U.S.A.

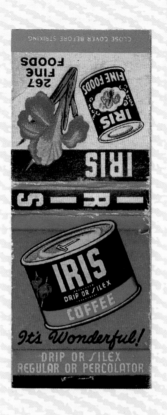
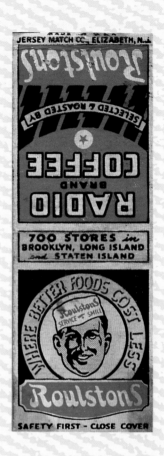

CLOSE COVER BEFORE STRIKING

FINE FOODS
267
FINE FOODS
IRIS

IRIS

S — R — S

IRIS
DRIP OR SILEX
COFFEE

It's Wonderful!

DRIP OR SILEX
REGULAR OR PERCOLATOR

JERSEY MATCH CO., ELIZABETH, N.J.

Roulstons

SELECTED & ROASTED BY

RADIO
BRAND
COFFEE

700 STORES in
BROOKLYN, LONG ISLAND
and STATEN ISLAND

WHERE BETTER FOODS COST LESS

Roulstons
SERVICE and SMILE

Roulstons

SAFETY FIRST - CLOSE COVER

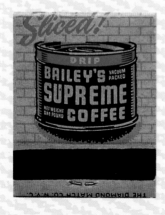

Sliced!
DRIP
BAILEY'S VACUUM PACKED
SUPREME
NET WEIGHT ONE POUND COFFEE

THE DIAMOND MATCH CO. N.Y.C.

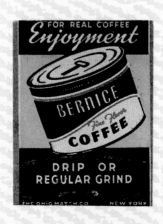

FOR REAL COFFEE
Enjoyment

BERNICE
Fine Flavor
COFFEE

DRIP OR
REGULAR GRIND

THE OHIO MATCH CO. NEW YORK

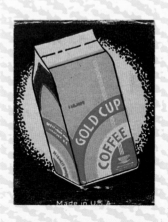

GOLD CUP
COFFEE

Made in U.S.A.

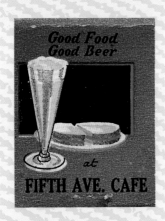

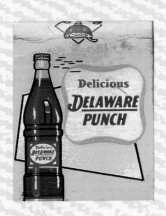

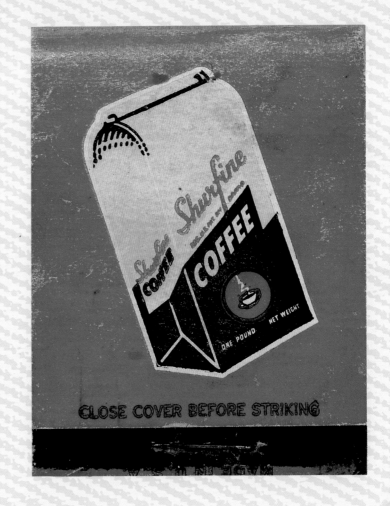

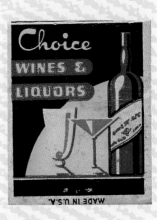

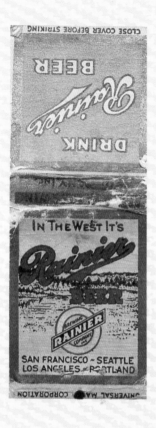

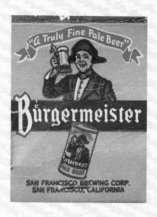

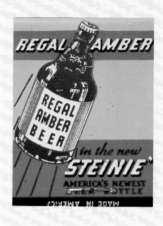

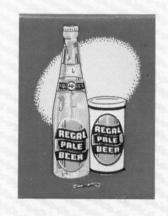

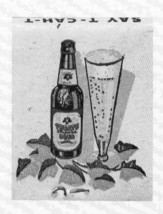

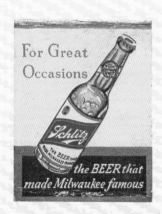

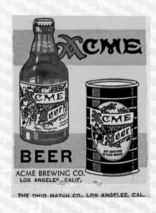

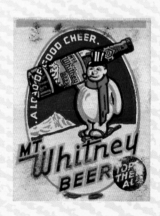

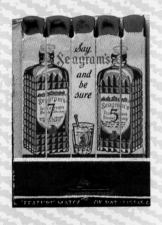

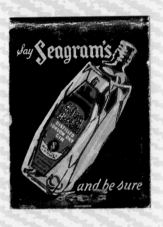

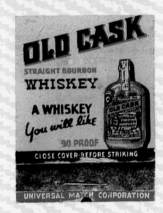

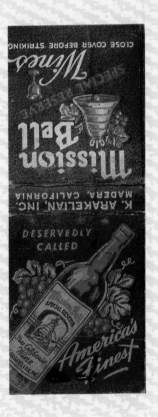

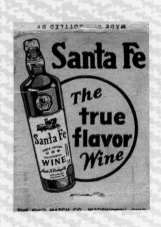

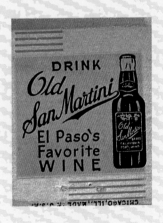

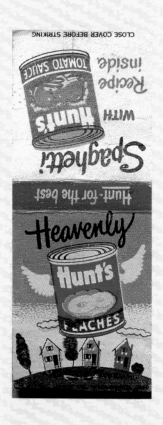

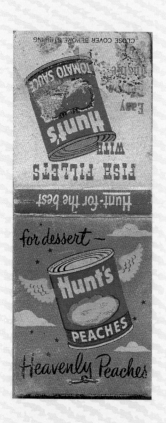

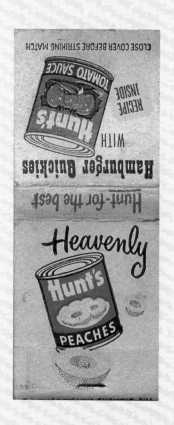

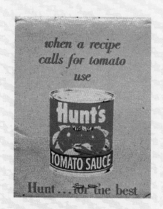

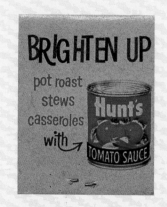

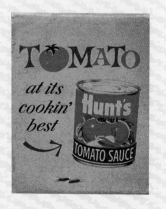

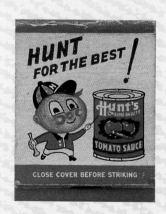

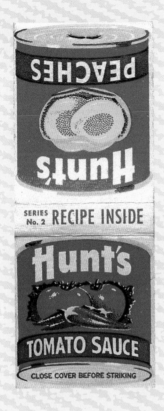

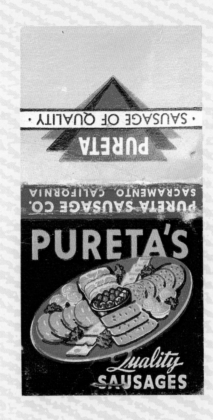

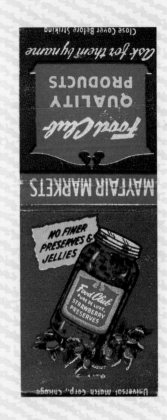

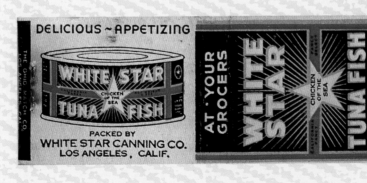

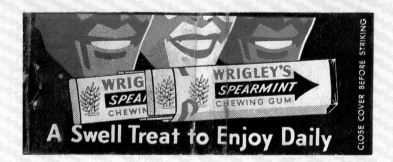

A Swell Treat to Enjoy Daily

CLOSE COVER BEFORE STRIKING

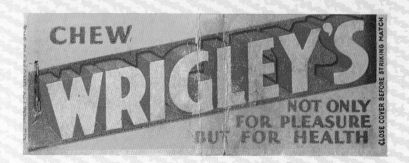

CHEW WRIGLEY'S

NOT ONLY FOR PLEASURE BUT FOR HEALTH

CLOSE COVER BEFORE STRIKING MATCH

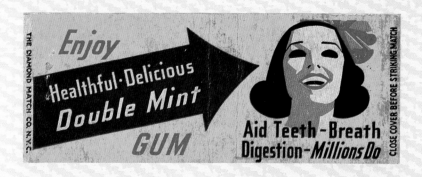

THE DIAMOND MATCH CO. N.Y.C.

Enjoy Healthful-Delicious Double Mint GUM

Aid Teeth-Breath Digestion—Millions Do

CLOSE COVER BEFORE STRIKING MATCH

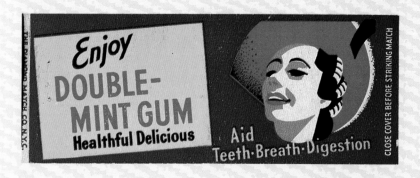

THE DIAMOND MATCH CO. N.Y.C.

Enjoy DOUBLE-MINT GUM Healthful Delicious

Aid Teeth-Breath-Digestion

CLOSE COVER BEFORE STRIKING MATCH

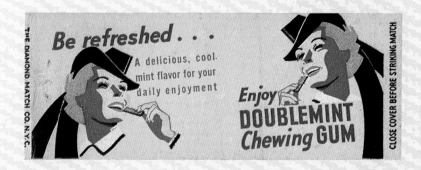

THE DIAMOND MATCH CO. N.Y.C.

Be refreshed . . .

A delicious, cool mint flavor for your daily enjoyment

Enjoy DOUBLEMINT Chewing GUM

CLOSE COVER BEFORE STRIKING MATCH

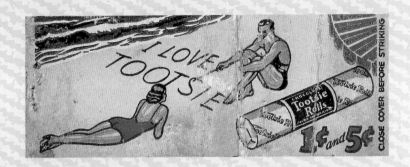

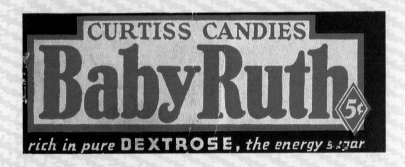

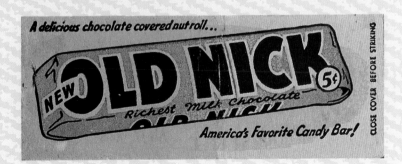

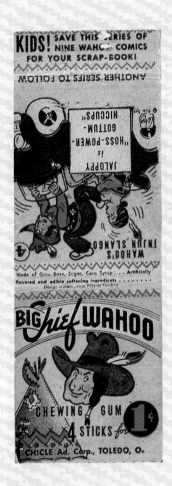

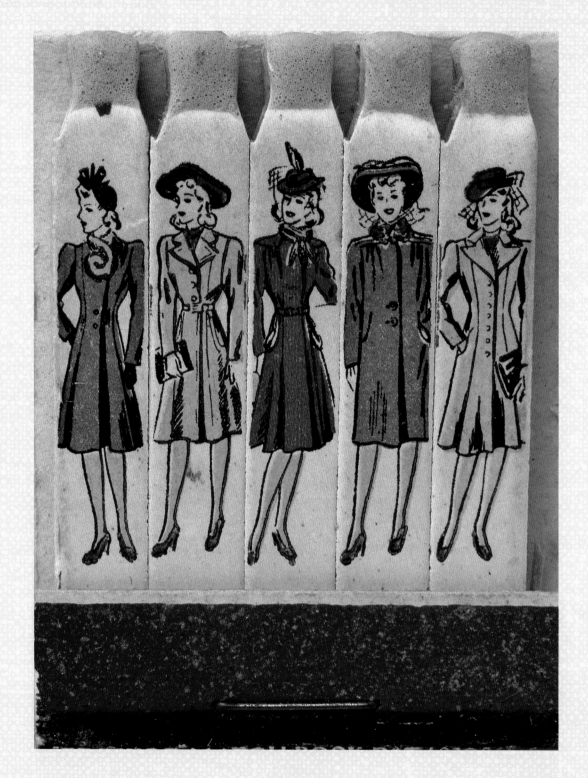

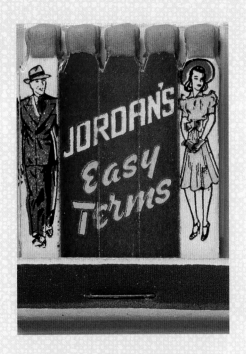

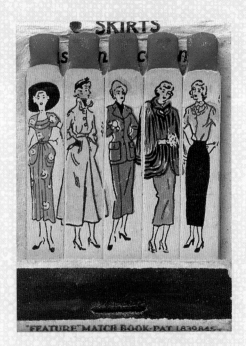

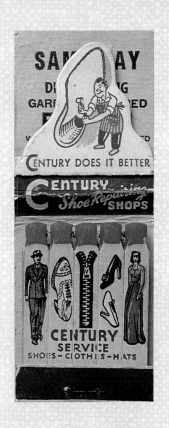

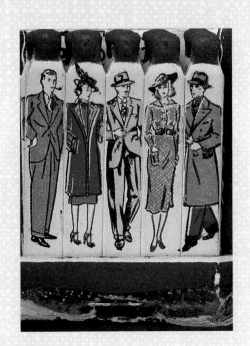

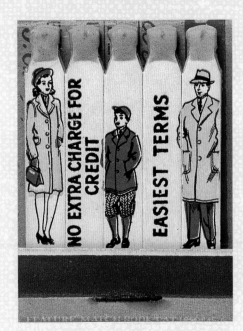

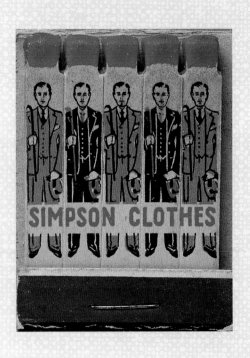

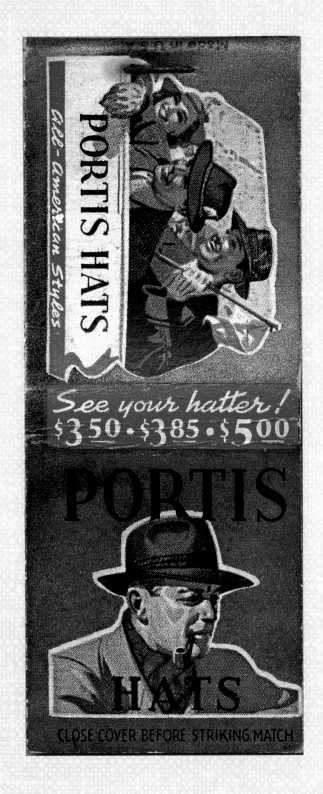

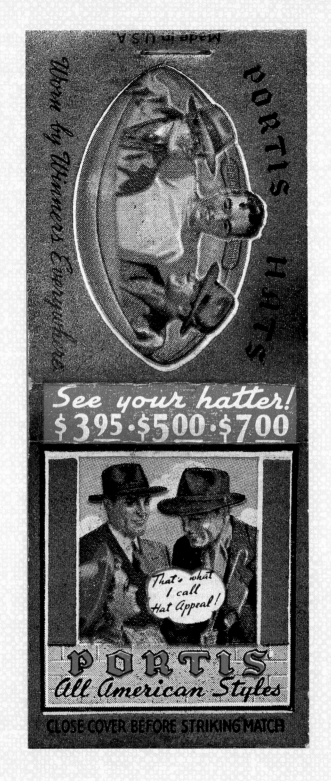

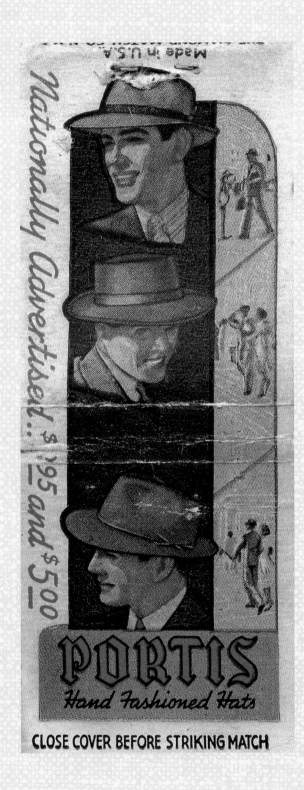

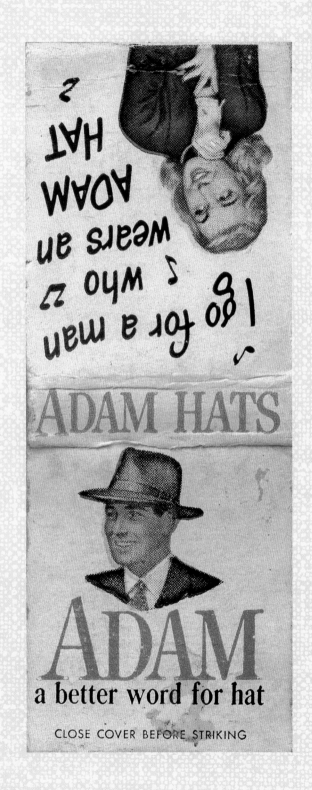

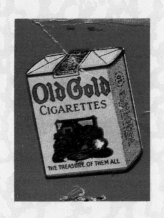

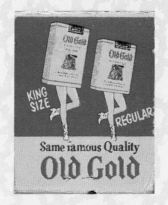

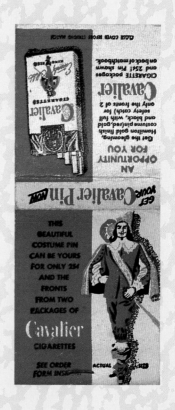

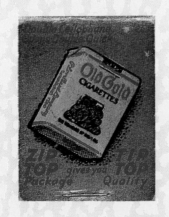

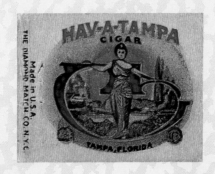

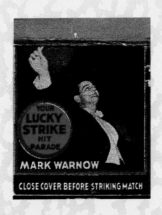

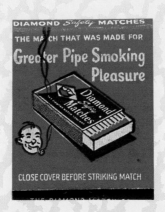

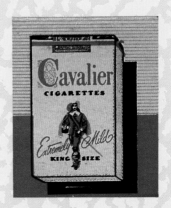

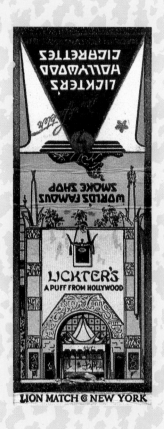

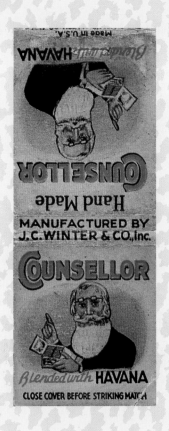

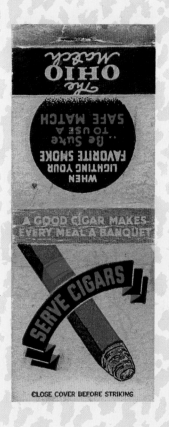

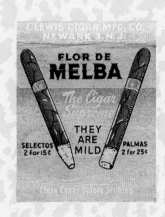

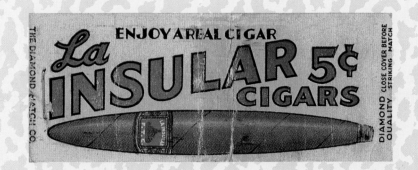

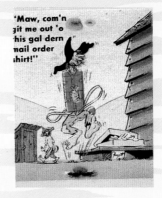

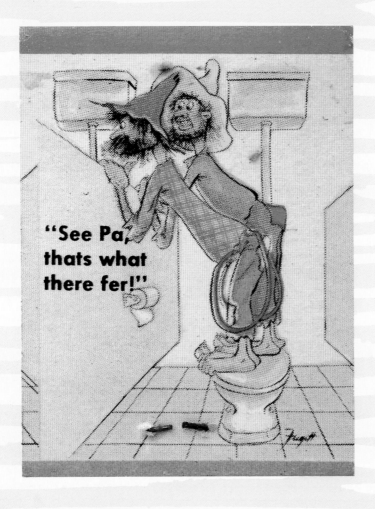

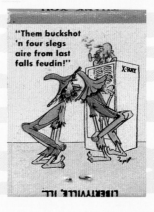

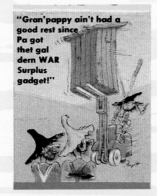

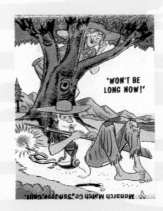

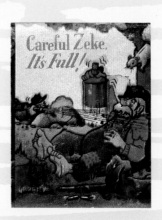

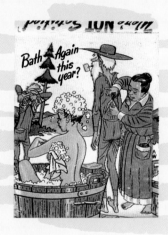
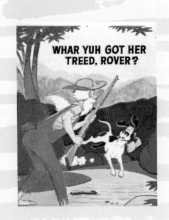
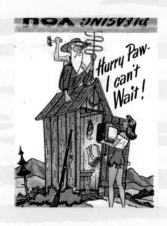
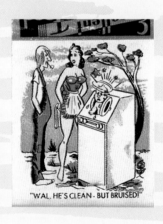

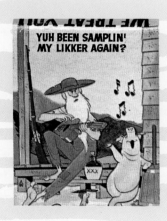
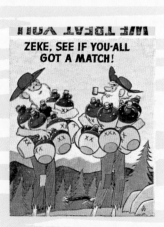
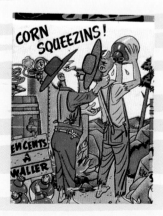
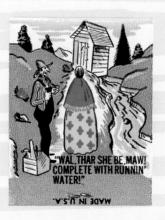

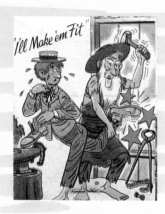

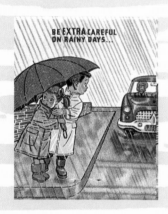

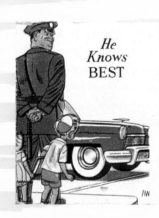

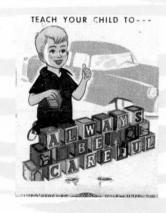

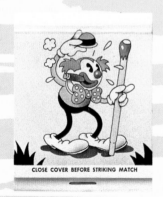

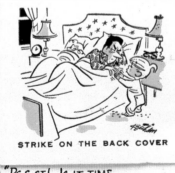

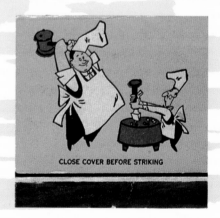

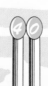

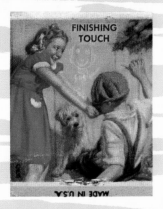

FINISHING
TOUCH

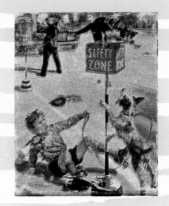

SAFETY
ZONE

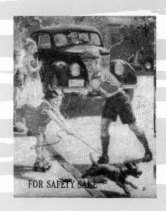

FOR SAFETY SAKE

WHAT A MESS

DEFENDERS OF AMERICA!

A DOG'S
BEST FRIEND!

CASEY AT THE BAT

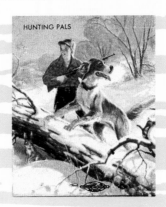

HUNTING PALS

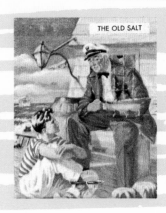

THE OLD SALT

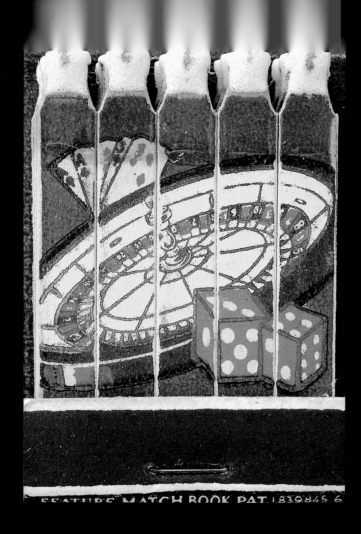

FEATURE MATCH BOOK PAT. 1839845 6

Close Cover Before Striking

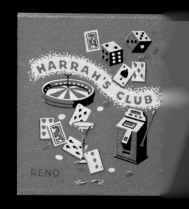

HARRAH'S CLUB

RENO

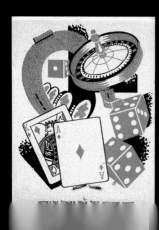

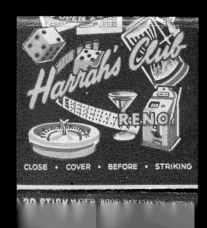

Harrah's Club

RENO

CLOSE · COVER · BEFORE · STRIKING

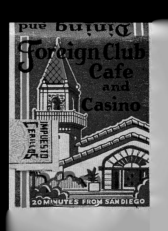

Dining and

Foreign Club
Cafe
and
Casino

IMPUESTO CERILLOS

20 MINUTES FROM SAN DIEGO

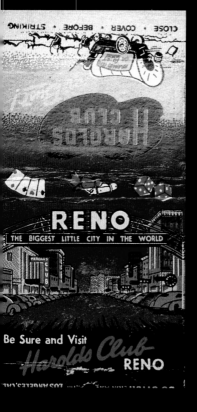

HAROLDS CLUB

RENO

THE BIGGEST LITTLE CITY IN THE WORLD

Be Sure and Visit *Harolds Club* RENO

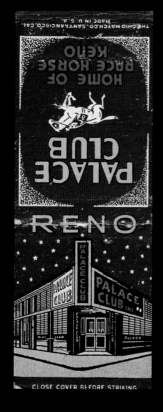

THE OHIO MATCH CO., SAN FRANCISCO, CAL. MADE IN U.S.A.

HOME OF RACE HORSE KENO

PALACE CLUB

RENO

PALACE CLUB INC.

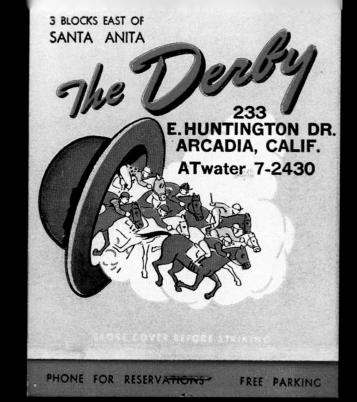

3 BLOCKS EAST OF SANTA ANITA

The Derby

233 E. HUNTINGTON DR. ARCADIA, CALIF. ATwater 7-2430

PHONE FOR RESERVATIONS FREE PARKING

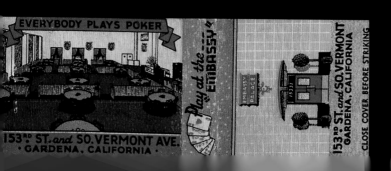

EVERYBODY PLAYS POKER

Play at the --- EMBASSY

153RD ST. and SO. VERMONT AVE. · GARDENA, CALIFORNIA ·

153RD ST. and SO. VERMONT, GARDENA, CALIFORNIA

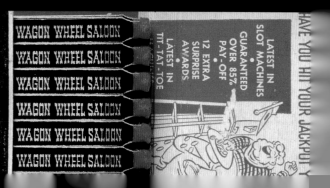

WAGON WHEEL SALOON
WAGON WHEEL SALOON
WAGON WHEEL SALOON
WAGON WHEEL SALOON
WAGON WHEEL SALOON
WAGON WHEEL SALOON

LATEST IN SLOT MACHINES GUARANTEED OVER 85% PAY-OFF
12 EXTRA SURPRISE AWARDS
LATEST IN TIT-TAT-TOE

HAVE YOU HIT YOUR JACKPOT?

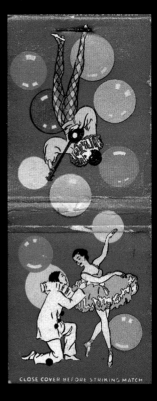

CLOSE COVER BEFORE STRIKING MATCH

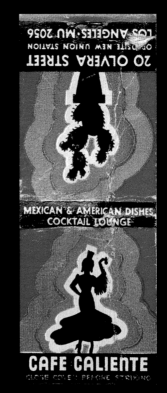

20 OLVERA STREET
LOS ANGELES · MU 2056
OPPOSITE NEW UNION STATION

MEXICAN & AMERICAN DISHES
COCKTAIL LOUNGE

CAFE CALIENTE

CLOSE COVER BEFORE STRIKING

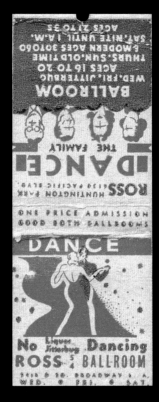

BALLROOM
WED., FRI., JITTERBUG
ACES 16 TO 20
THURS., SUN., OLD TIME
& MODERN ACES 30 TO 50
SAT., NITE UNTIL 1 A.M.
ACES 21 TO 35

DANCE THE FAMILY

ROSS
HUNTINGTON PARK
6139 PACIFIC BLVD.

ONE PRICE ADMISSION
GOOD BOTH BALLROOMS

DANCE

No Liquor Dancing
ROSS BALLROOM
WED. · FRI. · SAT.

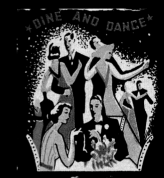

★ DINE AND DANCE ★

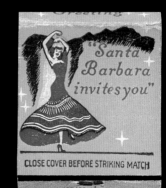

"Santa Barbara invites you"

CLOSE COVER BEFORE STRIKING MATCH

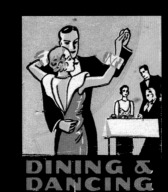

DINING &
DANCING

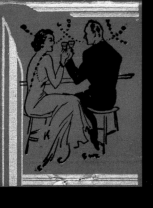

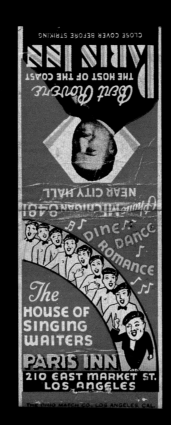

PARIS INN
THE HOST OF THE COAST
Bert Rovero

NEAR CITY HALL
Phone MICHIGAN 0401

DINE
DANCE
Romance

The
HOUSE OF
SINGING
WAITERS
PARIS INN
210 EAST MARKET ST.
LOS ANGELES

THE OHIO MATCH CO., LOS ANGELES, CAL.

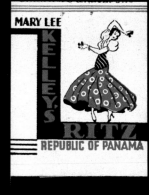

MARY LEE
KELLEY'S
RITZ
REPUBLIC OF PANAMA

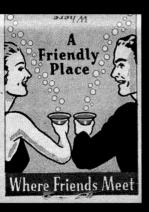

Where
A
Friendly
Place

Where Friends Meet

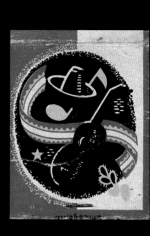

TEN MINUTES

Quad Hall
CLEVELAND'S
CLUB RESIDENCE
FOR MEN

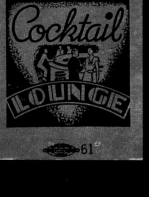

Cocktail
LOUNGE
61

BRODERICK'S BAR

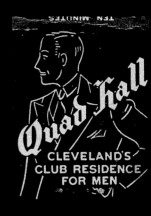

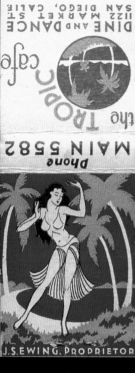

the TROPIC cafe

DINE AND DANCE
1122 MARKET ST
SAN DIEGO, CALIF

Phone MAIN 5582

J.S.EWING, PROPRIETOR

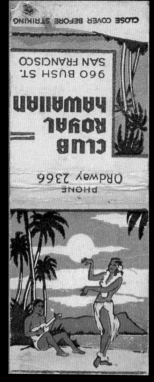

CLOSE COVER BEFORE STRIKING

CLUB
ROYAL
hawaiian

960 BUSH ST.
SAN FRANCISCO

PHONE
ORdway 2366

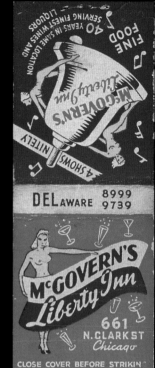

FINE FOOD
40 YEARS IN SAME LOCATION
SERVING FINEST WINES AND
LIQUORS

McGOVERN'S Liberty Inn

4 SHOWS NITELY

DELaware 8999
9739

McGOVERN'S
Liberty Inn

661
N. CLARK ST
Chicago

CLOSE COVER BEFORE STRIKIN

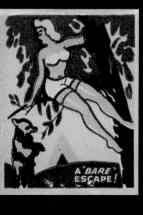

A "BARE"
ESCAPE!

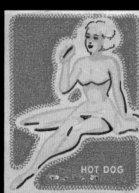

HOT DOG

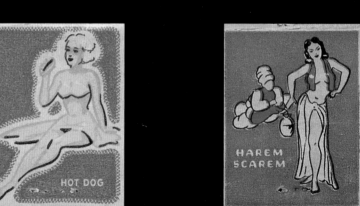

HAREM
SCAREM

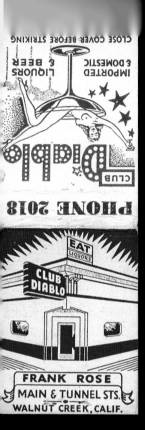

CLOSE COVER BEFORE STRIKING

IMPORTED & DOMESTIC
LIQUORS & BEER

CLUB Diablo

PHONE 2018

EAT
LIQUORS
CLUB
DIABLO

FRANK ROSE
MAIN & TUNNEL STS.
WALNUT CREEK, CALIF.

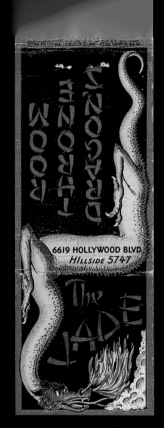

JADE ROOM

6619 HOLLYWOOD BLVD.
HILLSIDE 5747

The JADE

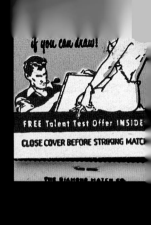

if you can draw!

FREE Talent Test Offer INSIDE

CLOSE COVER BEFORE STRIKING MATCH

THE DIAMOND MATCH CO.

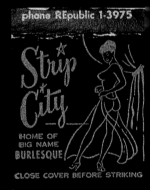

phone REpublic 1-3975

Strip City

HOME OF
BIG NAME
BURLESQUE

CLOSE COVER BEFORE STRIKING

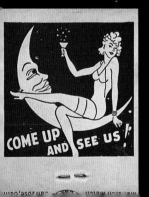

COME UP AND SEE US!

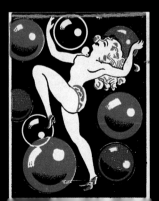

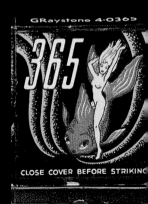

GRaystone 4-0365

365

CLOSE COVER BEFORE STRIKING

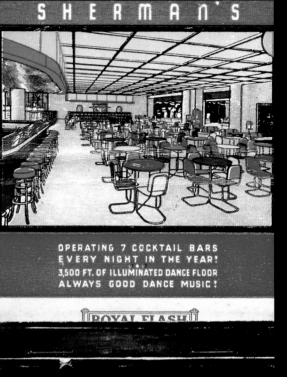

SHERMAN'S

OPERATING 7 COCKTAIL BARS
EVERY NIGHT IN THE YEAR!
3,500 FT. OF ILLUMINATED DANCE FLOOR
ALWAYS GOOD DANCE MUSIC!

ROYAL FLASH

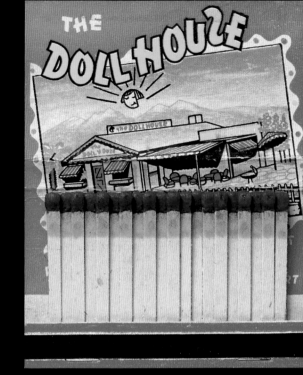

THE DOLLHOUSE

the DOLLHOUSE

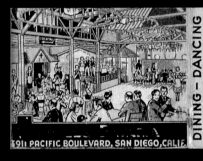

3911 PACIFIC BOULEVARD, SAN DIEGO, CALIF.

DINING – DANCING
ENTERTAINMENT

CLOSE COVER BEFORE STRIKING

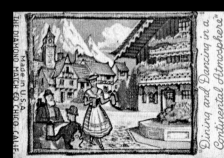

Made in U.S.A.
THE DIAMOND MATCH CO. CHICO, CALIF.

"Dining and Dancing in a
Continental Atmosphere"

Alpine Village

6300 WILSHIRE BLVD. LOS ANGELES

CLOSE COVER BEFORE STRIKING MATCH

FINE
FOODS
AND
COCKTAILS

ENTERTAINMENT

The
Joyous
SPOT
in town

LITTLE JOE'S
RESTAURANT · GROCERIES
COCKTAIL BAR

THE OHIO MATCH CO., WADSWORTH, OHIO.

DINE and DANCE DeLuxe ENTERTAINMENT

The Ranch

8-MILES NORTH of SEATTLE on NEW EVERETT HI-WAY

THE OHIO MATCH CO.

CLOSE, COVER BEFORE STRIKING

Hollywood Recreation
1539 N. VINE ST. HOLLYWOOD, CALIF.

BOWLING · BILLIARDS · COCKTAIL LOUNGE · CAFE

CLOSE COVER BEFORE STRIKING

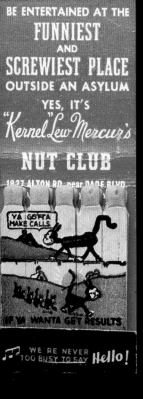

BE ENTERTAINED AT THE
FUNNIEST
AND
SCREWIEST PLACE
OUTSIDE AN ASYLUM
YES, IT'S
"Kernel" Lew Mercur's
NUT CLUB
1827 ALTON RD. near DADE BLVD.

YA GOTTA
MAKE CALLS

IF YA WANTA GET RESULTS

WE'RE NEVER
TOO BUSY TO SAY **Hello!**

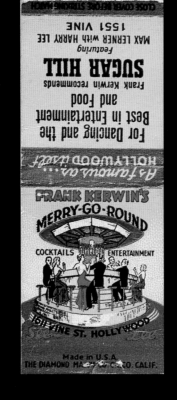

CLOSE COVER BEFORE STRIKING MATCH

1551 VINE
MAX LERNER with HARRY LEE
Featuring
SUGAR HILL
Frank Kerwin recommends
and
Food
Best in Entertainment
and the
For Dancing and

As famous as ...HOLLYWOOD *itself*

FRANK KERWIN'S
MERRY-GO-ROUND
COCKTAILS ENTERTAINMENT

1511 VINE ST. HOLLYWOOD

See

Made in U.S.A
THE DIAMOND MATCH CO. CHICO. CALIF.

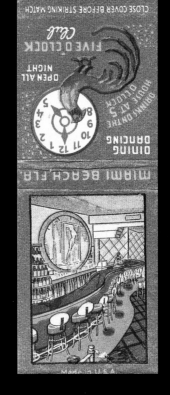

CLOSE COVER BEFORE STRIKING MATCH

FIVE O'CLOCK
Club
OPEN ALL
NIGHT
HOUSE ON THE
DRIVE AT 5 O'CLOCK
DANCING
DINING

MIAMI BEACH, FLA.

Made in U.S.A.

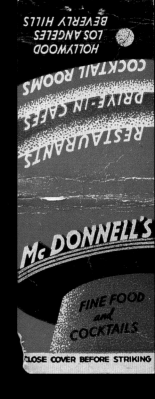

BEVERLY HILLS
LOS ANGELES
HOLLYWOOD

COCKTAIL ROOMS
DRIVE-IN CAFES
RESTAURANTS

McDONNELL'S
FINE FOOD
and
COCKTAILS

CLOSE COVER BEFORE STRIKING

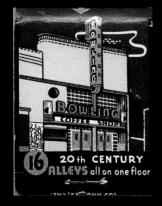

BOWLING
COFFEE SHOP
16 20th CENTURY
ALLEYS all on one floor

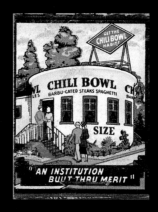

GET THE
CHILI BOWL
HABIT
CHILI BOWL
BARBU-CATED STEAKS SPAGHETTI
SIZE
*"AN INSTITUTION
BUILT THRU MERIT"*

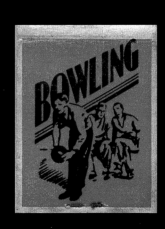

BOWLING

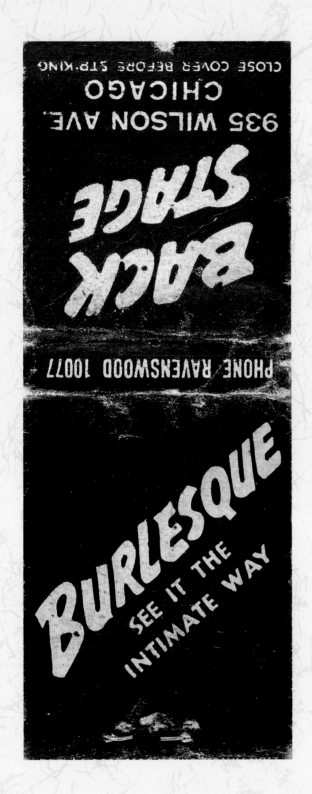

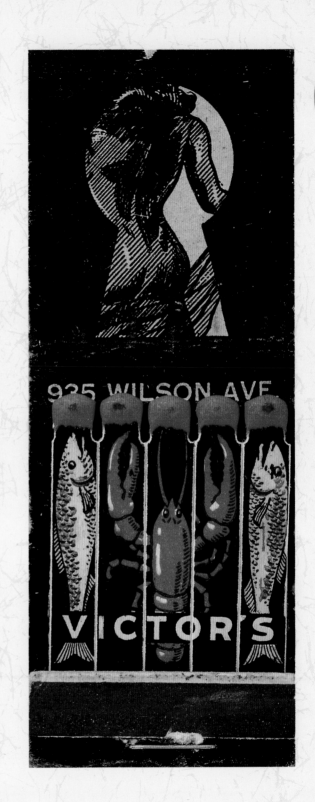

Peeping

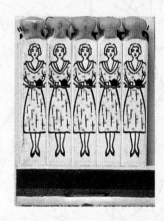
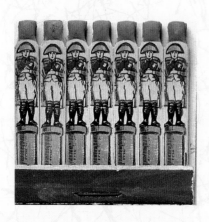
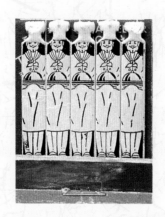
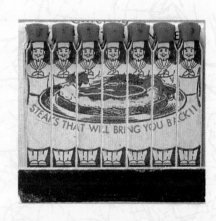
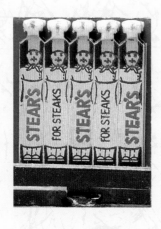
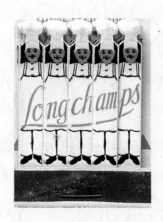
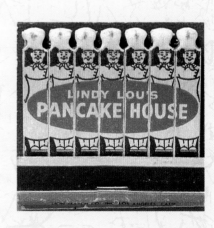

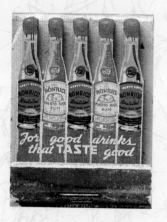

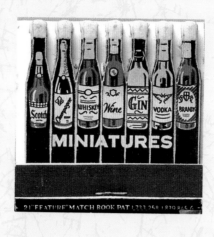

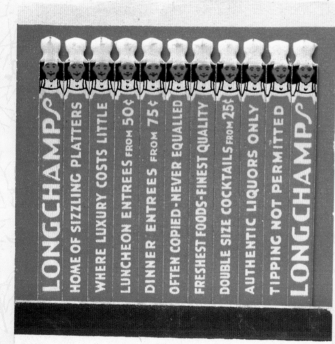

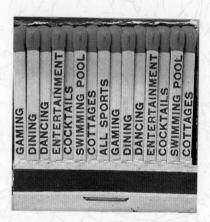

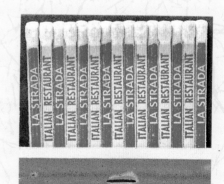

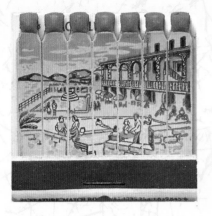

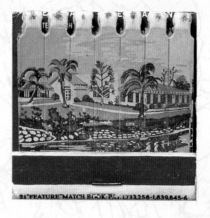

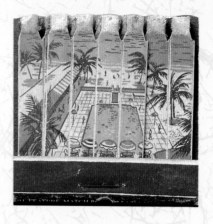

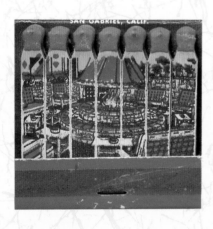

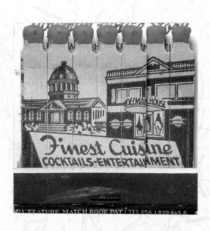

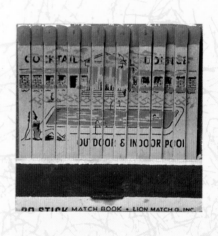

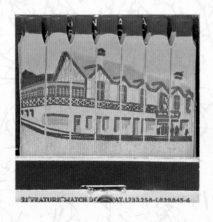

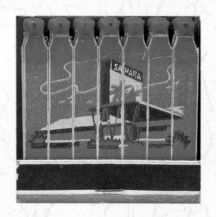

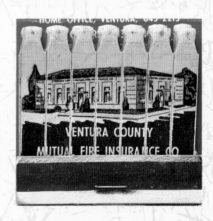

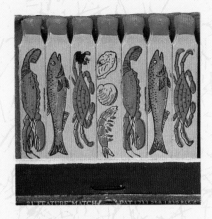

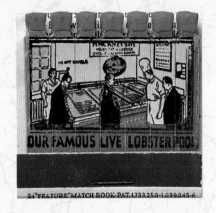

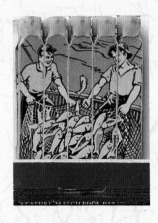

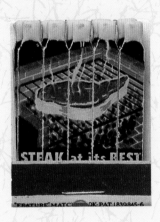

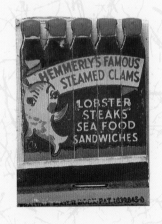

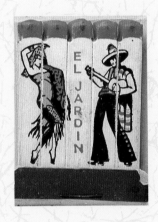

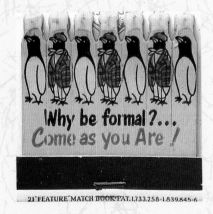

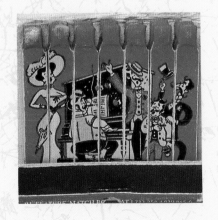

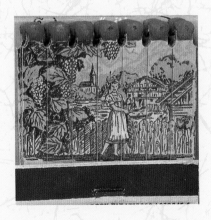

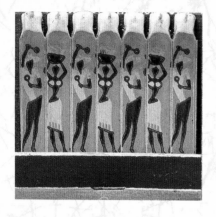 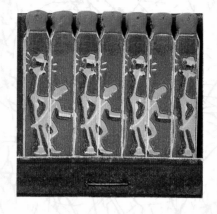 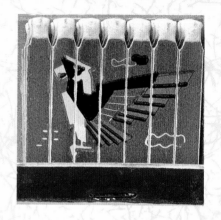

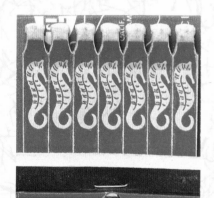 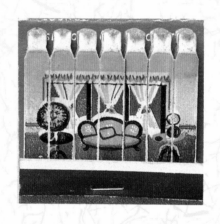 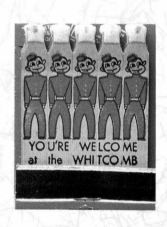

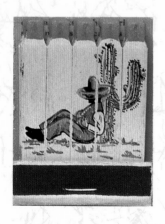 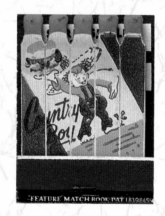 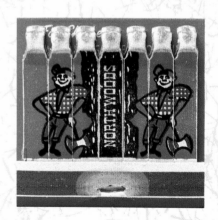

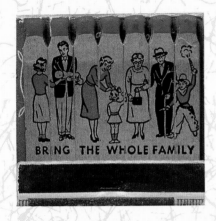

BRING THE WHOLE FAMILY

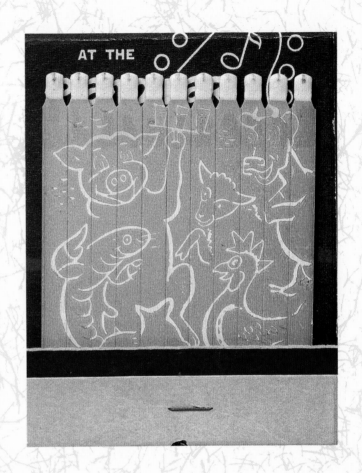

AT THE

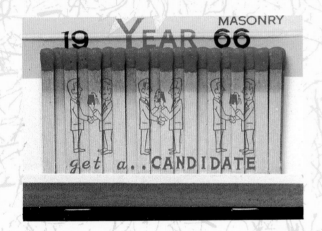

19 YEAR 66 MASONRY

get a.. CANDIDATE

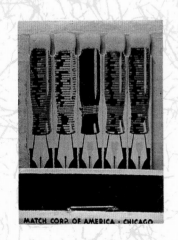

MATCH CORP OF AMERICA · CHICAGO

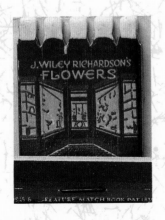

J.WILEY RICHARDSON'S
FLOWERS

FEATURE MATCH BOOK PAT (1)

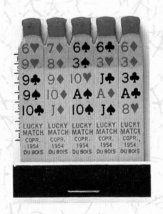

6♥	7♦	6♠	6♣	6♦
9♥	8♦	3♠	3♥	3♦
9♣	9♦	10♥	J♣	3♣
9♠	10♦	A♠	A♦	A♣
10♣	J♦	10♠	J♣	8♥
LUCKY MATCH COPR. 1954 DU BOIS	LUCKY MATCH COPR. 1954 DU BOIS	LUCKY MATCH COPR. 1954 DU BOIS	LUCKY MATCH COPR. 1954 DU BOIS	LUCKY MATCH COPR. 1954 DU BOIS

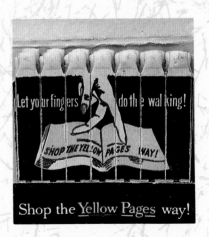

Let your fingers do the walking!

SHOP THE YELLOW PAGES WAY!

Shop the Yellow Pages way!

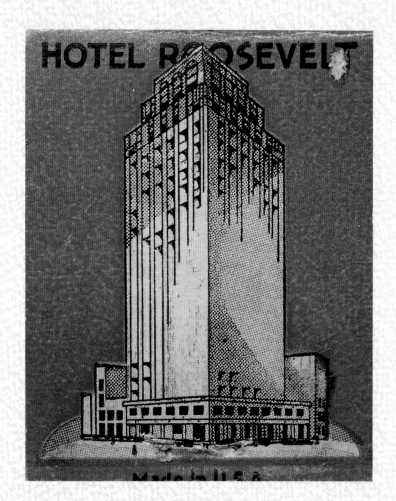

HOTEL ROOSEVELT

Made in U.S.A.

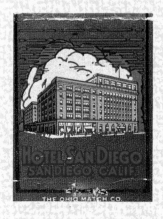

H

o t e l s

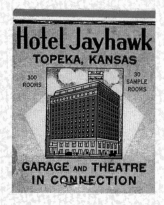

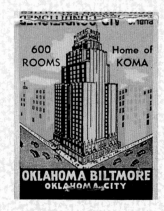

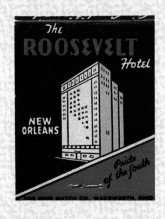

The
ROOSEVELT
Hotel

NEW
ORLEANS

Pride of the South

THE OHIO MATCH CO., WADSWORTH, OHIO

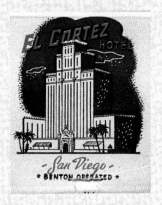

EL CORTEZ HOTEL

San Diego
· BENTON OPERATED ·

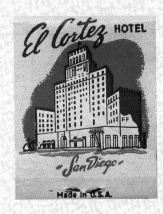

El Cortez HOTEL

San Diego

Made in U.S.A.

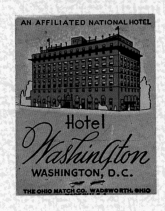

AN AFFILIATED NATIONAL HOTEL

Hotel
Washington
WASHINGTON, D.C.

THE OHIO MATCH CO., WADSWORTH, OHIO

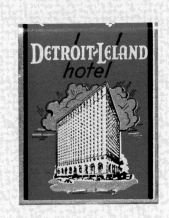

DETROIT·LELAND
hotel

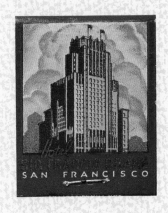

SAN FRANCISCO

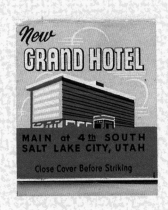

New
GRAND HOTEL

MAIN at 4th SOUTH
SALT LAKE CITY, UTAH

Close Cover Before Striking

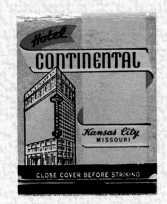

Hotel
CONTINENTAL

Kansas City
MISSOURI

CLOSE COVER BEFORE STRIKING

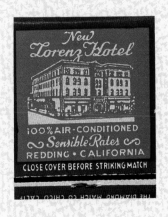

New
Lorenz Hotel

100% AIR-CONDITIONED
Sensible Rates
REDDING · CALIFORNIA
CLOSE COVER BEFORE STRIKING MATCH

THE DIAMOND MATCH CO. CHICO, CALIF.

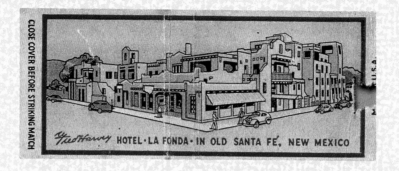

HOTEL · LA FONDA · IN OLD SANTA FE, NEW MEXICO

CLOSE COVER BEFORE STRIKING MATCH

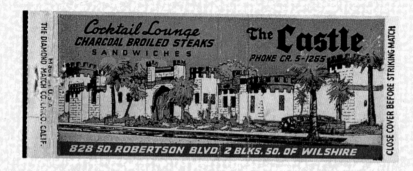

Cocktail Lounge
CHARCOAL BROILED STEAKS
SANDWICHES

The **Castle**
PHONE CR. 5-1255

828 SO. ROBERTSON BLVD. 2 BLKS. SO. OF WILSHIRE

Made in U.S.A.
THE DIAMOND MATCH CO. CHICO. CALIF.

CLOSE COVER BEFORE STRIKING MATCH

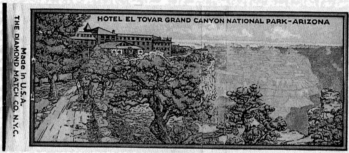

HOTEL EL TOVAR GRAND CANYON NATIONAL PARK—ARIZONA

Made in U.S.A.
THE DIAMOND MATCH CO. N.Y.C.

CLOSE COVER BEFORE STRIKING MATCH

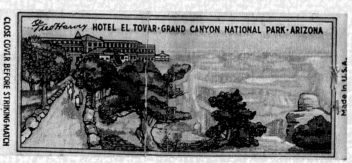

HOTEL EL TOVAR · GRAND CANYON NATIONAL PARK · ARIZONA

CLOSE COVER BEFORE STRIKING MATCH

Made in U.S.A.

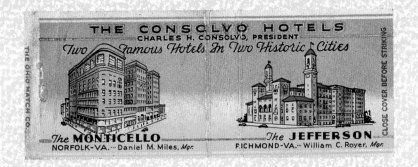

THE CONSOLVO HOTELS
CHARLES H. CONSOLVO, PRESIDENT
Two Famous Hotels In Two Historic Cities

The **MONTICELLO**
NORFOLK-VA.—Daniel M. Miles, *Mgr.*

The **JEFFERSON**
RICHMOND-VA.—William C. Royer, *Mgr.*

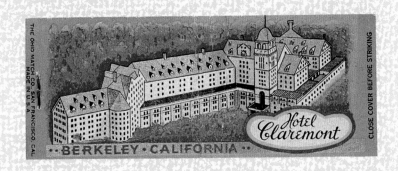

The **PLAINS** HOTEL
CHEYENNE, WYO.

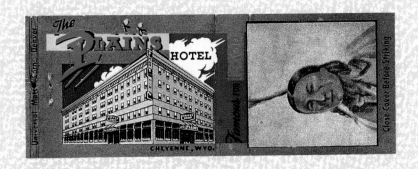

Hotel *Claremont*
• BERKELEY · CALIFORNIA •

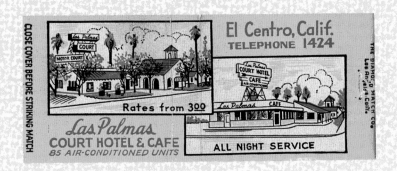

El Centro, Calif.
TELEPHONE 1424

Rates from 3.00

Las Palmas
COURT HOTEL & CAFE
85 AIR-CONDITIONED UNITS

ALL NIGHT SERVICE

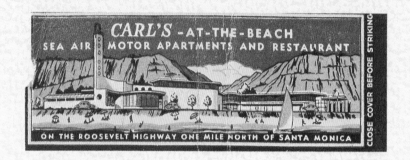

CARL'S -AT-THE-BEACH
SEA AIR MOTOR APARTMENTS AND RESTAURANT

ON THE ROOSEVELT HIGHWAY ONE MILE NORTH OF SANTA MONICA

CLOSE COVER BEFORE STRIKING

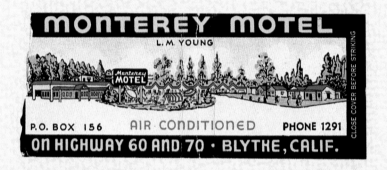

MONTEREY MOTEL
L. M. YOUNG

P.O. BOX 156 AIR CONDITIONED PHONE 1291

ON HIGHWAY 60 AND 70 · BLYTHE, CALIF.

CLOSE COVER BEFORE STRIKING

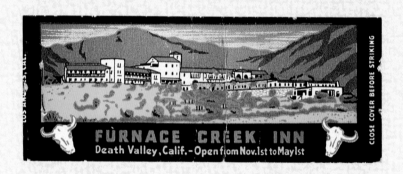

FURNACE CREEK INN
Death Valley, Calif. - Open from Nov. 1st to May 1st

CLOSE COVER BEFORE STRIKING

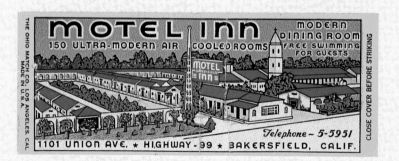

MOTEL inn
150 ULTRA-MODERN AIR COOLED ROOMS

MODERN DINING ROOM FREE SWIMMING FOR GUESTS

Telephone ~ 5-5951
1101 UNION AVE. ★ HIGHWAY-99 ★ BAKERSFIELD, CALIF.

THE OHIO MATCH CO. LOS ANGELES, CAL. MADE IN U.S.A.

CLOSE COVER BEFORE STRIKING

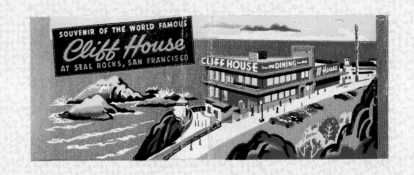

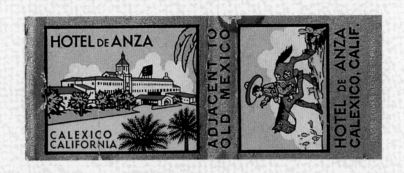

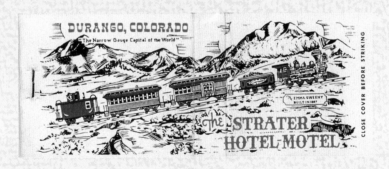

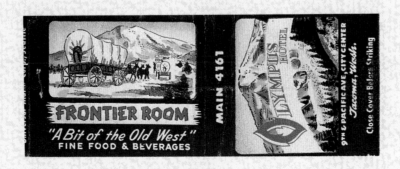

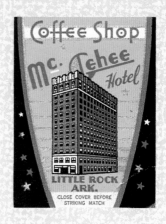

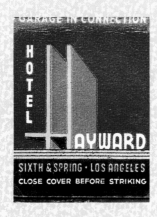

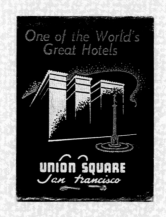

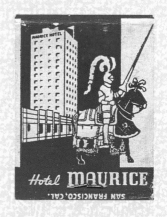

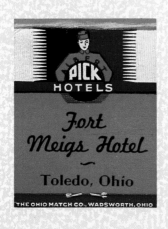

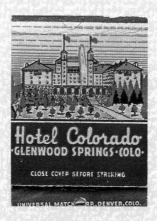

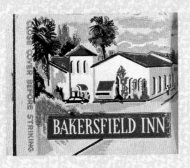

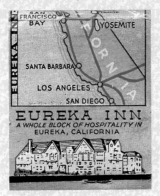

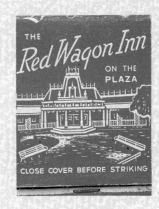

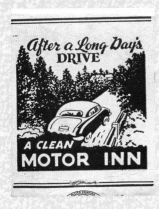

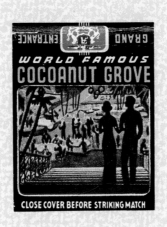

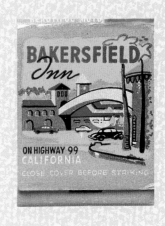

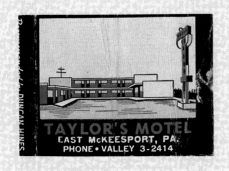

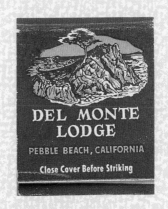

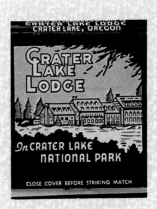

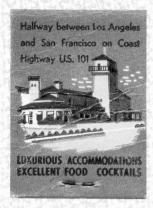

Halfway between Los Angeles and San Francisco on Coast Highway U.S. 101

LUXURIOUS ACCOMMODATIONS
EXCELLENT FOOD COCKTAILS

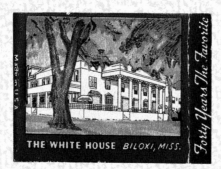

THE WHITE HOUSE BILOXI, MISS.

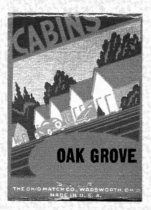

Forty Years The Favorite

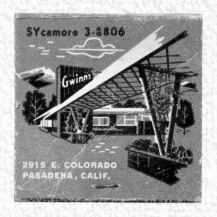

CABINS

OAK GROVE

THE OHIO MATCH CO., WADSWORTH, OHIO
MADE IN U.S.A.

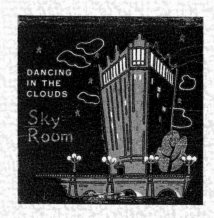

SYcamore 3-8806

Gwinn's

2915 E. COLORADO
PASADENA, CALIF.

DINNERS

Made in U.S.A.
THE OHIO MATCH CO., N.Y.C.

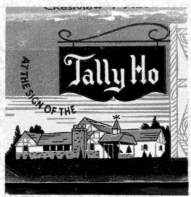

AT THE SIGN OF THE

Tally Ho

CLOSE COVER BEFORE STRIKING

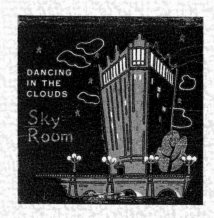

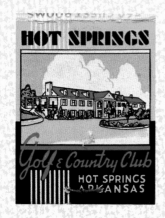

HOT SPRINGS

Golf & Country Club
HOT SPRINGS
ARKANSAS

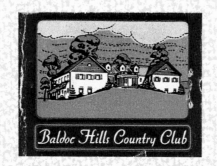

Baldoc Hills Country Club

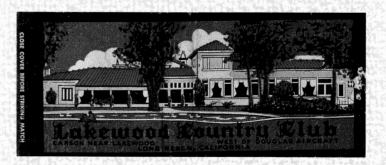

CLOSE COVER BEFORE STRIKING MATCH

Lakewood Country Club
CARSON NEAR LAKEWOOD WEST OF DOUGLAS AIRCRAFT
LONG BEACH, CALIFORNIA

DANCING
IN THE
CLOUDS

Sky
Room

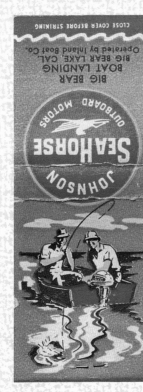

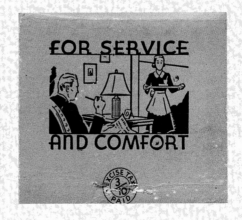

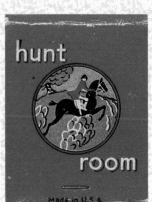

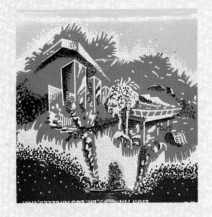

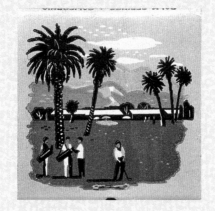

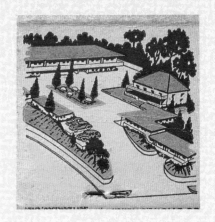

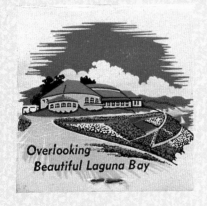

*Overlooking
Beautiful Laguna Bay*

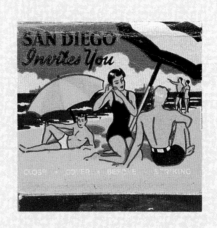

SAN DIEGO
Invites You

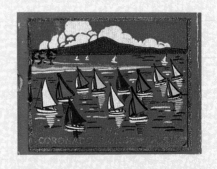

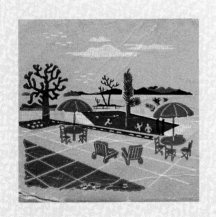

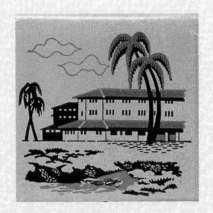

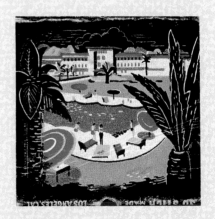

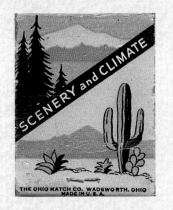

SCENERY and CLIMATE

THE OHIO MATCH CO., WADSWORTH, OHIO
MADE IN U.S.A.

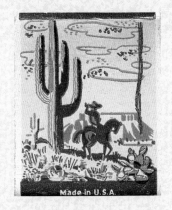

Made in U.S.A.

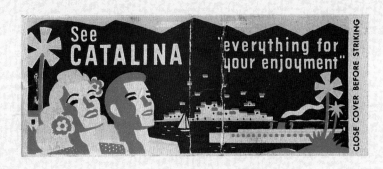

See CATALINA "everything for your enjoyment"

CLOSE COVER BEFORE STRIKING

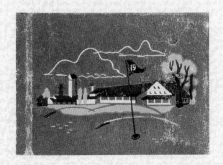

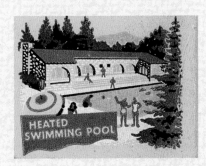

HEATED SWIMMING POOL

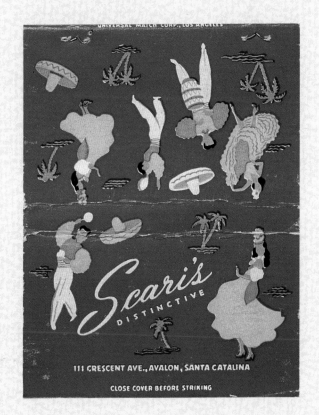

UNIVERSAL MATCH CORP., LOS ANGELES

Scari's DISTINCTIVE

111 CRESCENT AVE., AVALON, SANTA CATALINA

CLOSE COVER BEFORE STRIKING

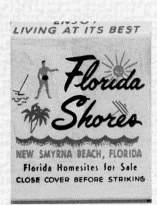

ENJOY LIVING AT ITS BEST

Florida Shores

NEW SMYRNA BEACH, FLORIDA
Florida Homesites for Sale
CLOSE COVER BEFORE STRIKING

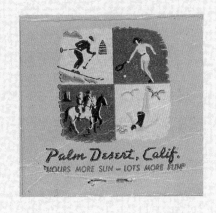

Palm Desert, Calif.
HOURS MORE SUN — LOTS MORE FUN

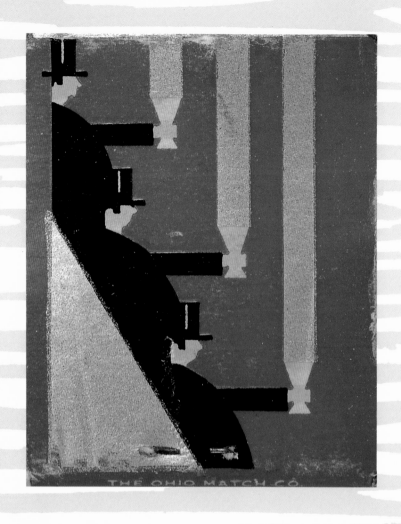

THE OHIO MATCH CO.

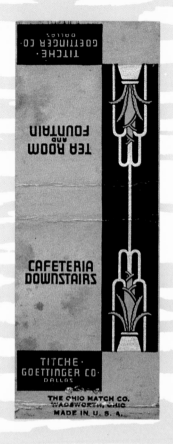

TITCHE · GOETTINGER CO · DALLAS

TEA ROOM AND FOUNTAIN

CAFETERIA DOWNSTAIRS

TITCHE · GOETTINGER CO · DALLAS

THE OHIO MATCH CO. WADSWORTH, OHIO MADE IN U. S. A.

Good Coffee

61

Dan's COFFEE CUP

Made in U.S.A.

H.

OMAHA, NEBR.

CLOSE COVER BEFORE STRIKING MATCH

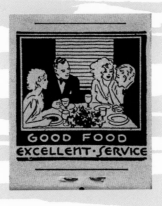

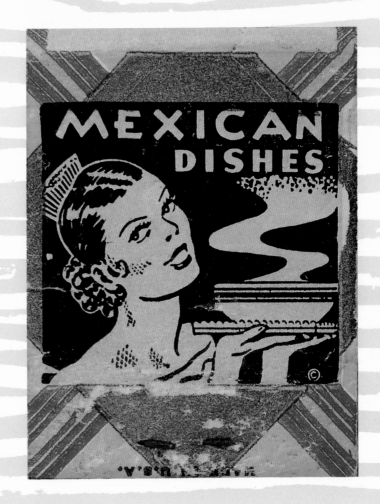

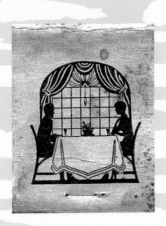

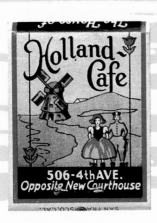

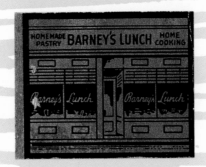

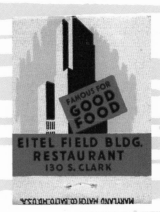

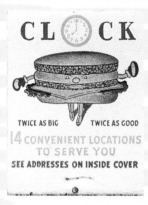

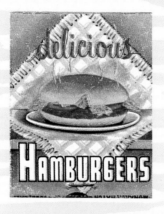

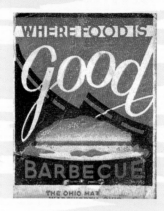

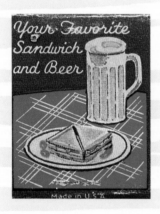

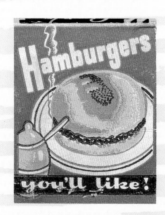

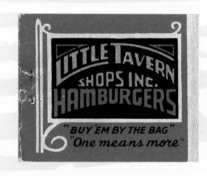

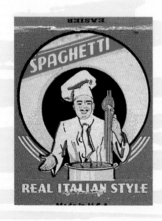

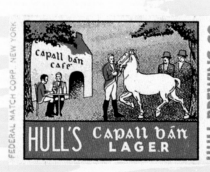

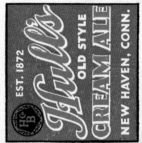

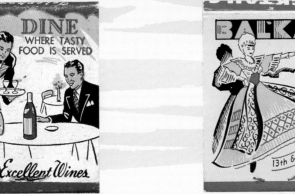

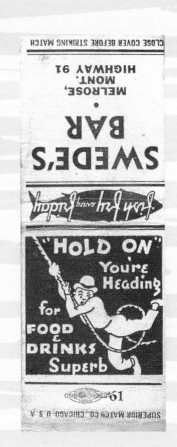

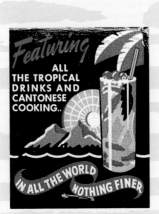

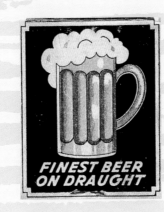

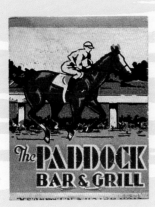

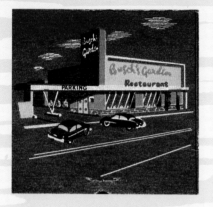

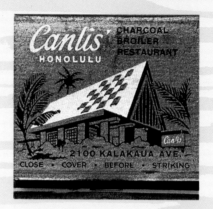

Canlis'
HONOLULU
CHARCOAL
BROILER
RESTAURANT

2100 KALAKAUA AVE.
CLOSE · COVER · BEFORE · STRIKING

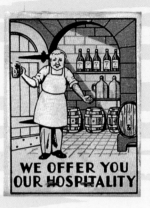

WE OFFER YOU
OUR HOSPITALITY

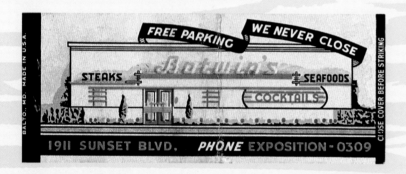

FREE PARKING WE NEVER CLOSE
Botwin's
STEAKS SEAFOODS
COCKTAILS
BALTO. MD. MADE IN U.S.A.
CLOSE COVER BEFORE STRIKING
1911 SUNSET BLVD. PHONE EXPOSITION - 0309

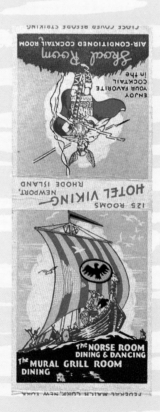

Sea Food Room
ENJOY YOUR FAVORITE COCKTAIL in the AIR-CONDITIONED COCKTAIL ROOM
HOTEL VIKING
NEWPORT, RHODE ISLAND
125 ROOMS
The NORSE ROOM DINING & DANCING
The MURAL GRILL ROOM DINING

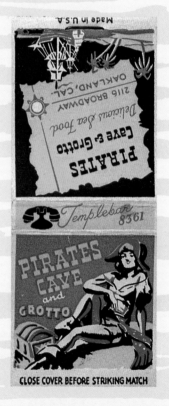

Made in U.S.A.
PIRATES Cave & Grotto
Delicious Sea Food
2116 BROADWAY
OAKLAND, CAL.

Templebar 8361
PIRATES CAVE and GROTTO
CLOSE COVER BEFORE STRIKING MATCH

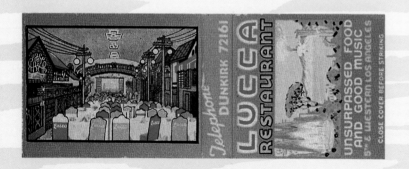

Telephone DUNKIRK 72161
LUCCA RESTAURANT
UNSURPASSED FOOD AND GOOD MUSIC
5TH & WESTERN Los Angeles
Close Cover Before Striking

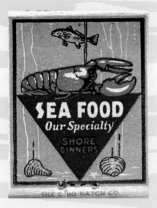

SEA FOOD
Our Specialty
SHORE DINNERS

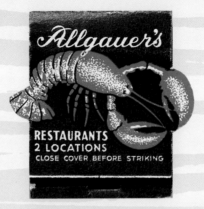

Allgauer's
RESTAURANTS
2 LOCATIONS
CLOSE COVER BEFORE STRIKING

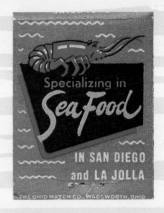

Specializing in
Sea Food
IN SAN DIEGO
and LA JOLLA

EL: LIBerty 3296
DEVonshire 7878
Sea Grill

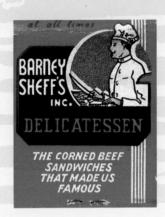

at all times
BARNEY SHEFF'S INC.
DELICATESSEN
THE CORNED BEEF SANDWICHES THAT MADE US FAMOUS

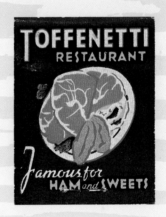

TOFFENETTI RESTAURANT
famous for HAM *and* SWEETS

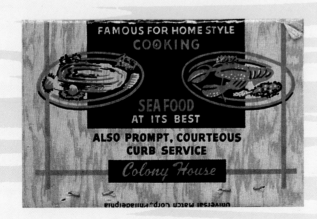

FAMOUS FOR HOME STYLE COOKING
SEA FOOD AT ITS BEST
ALSO PROMPT, COURTEOUS CURB SERVICE
Colony House

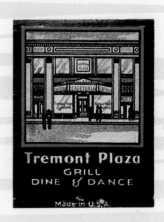

Tremont Plaza
GRILL
DINE & DANCE
Made in U.S.A.

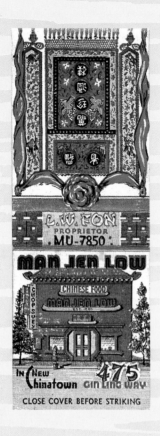

MAN JEN LOW

L.W. FON
PROPRIETOR
MU-7850

CHINESE FOOD
MAN JEN LOW
EST. 1880
CHOP SUEY

In New
Chinatown 475 GIN LING WAY

CLOSE COVER BEFORE STRIKING

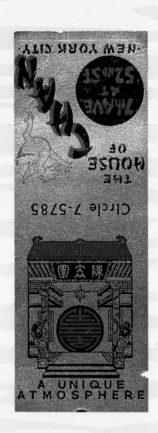

THE HOUSE OF
CHAN
7th AVE AT 52nd ST·
·NEW YORK CITY·

Circle 7-5785

A UNIQUE
ATMOSPHERE

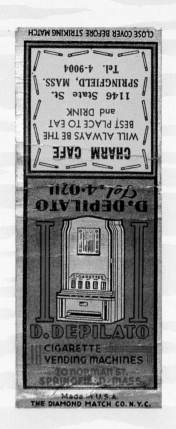

CLOSE COVER BEFORE STRIKING MATCH

CHARM CAFE
WILL ALWAYS BE THE
BEST PLACE TO EAT
and DRINK
1146 State St.
SPRINGFIELD, MASS.
Tel. 4-9004

D. DEPILATO
Tel. 4-0711

CIGARETTE

D. DEPILATO
CIGARETTE
VENDING MACHINES
20 NORMAN ST.
SPRINGFIELD, MASS.

Made in U.S.A.
THE DIAMOND MATCH CO. N.Y.C.

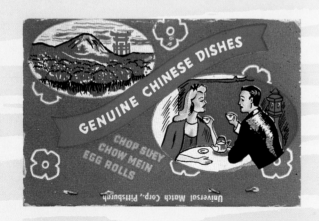

GENUINE CHINESE DISHES

CHOP SUEY
CHOW MEIN
EGG ROLLS

Universal Match Corp, Pittsburgh

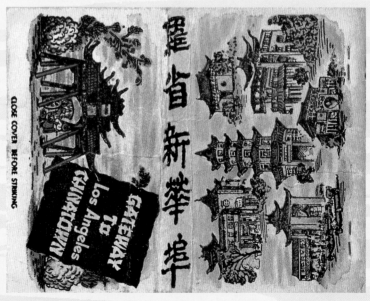

CLOSE COVER BEFORE STRIKING

GATEWAY
To
Los Angeles
CHINATOWN

羅省新華埠

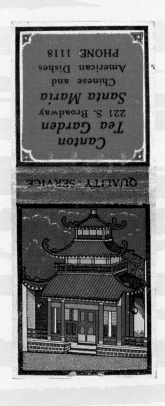

Canton
Tea Garden
221 S. Broadway
Santa Maria
Chinese and
American Dishes
PHONE 1118

QUALITY · SERVICE

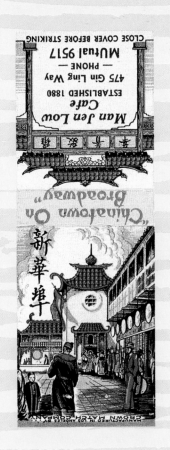

CLOSE COVER BEFORE STRIKING
Mutual 9517
— PHONE —
475 Gin Ling Way
ESTABLISHED 1880
Café
Man Jen Low

"Chinatown On Broadway"

新華埠

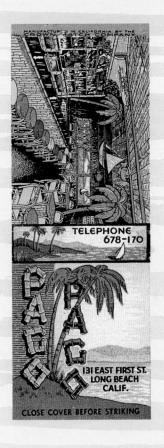

TELEPHONE
678-170

PAGO PAGO

131 EAST FIRST ST.
LONG BEACH
CALIF.

CLOSE COVER BEFORE STRIKING

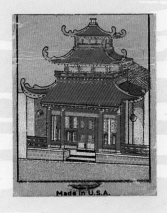

Made in U.S.A.

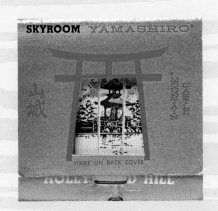

SKYROOM YAMASHIRO

山城

STRIKE ON BACK COVER

HOLLYWOOD HILL

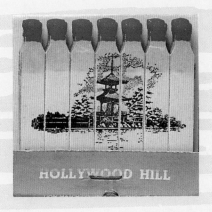

HOLLYWOOD HILL

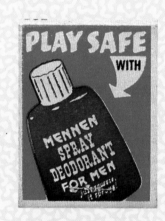

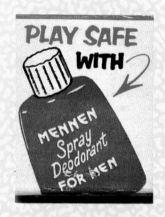

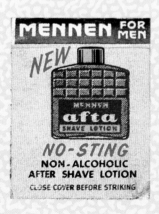

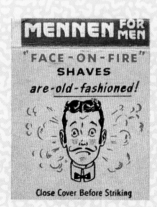

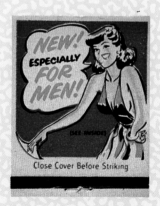

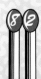

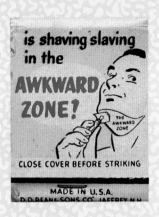

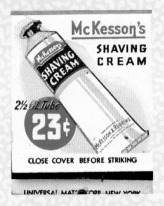

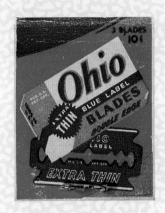

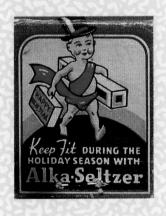

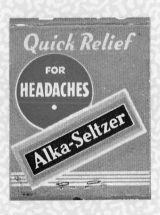

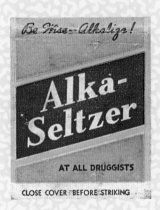

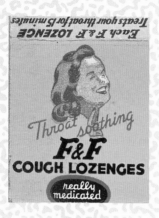

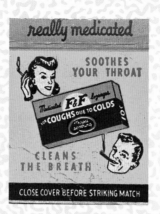

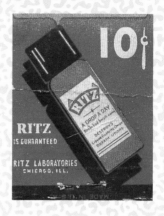

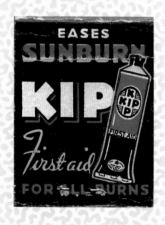

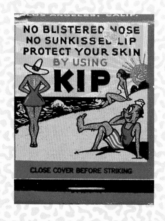

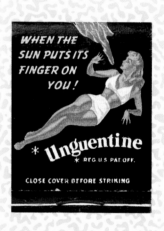

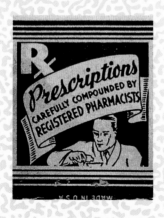

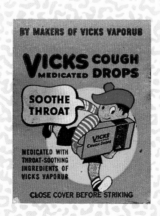

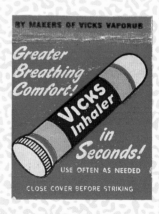

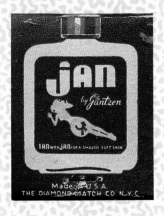

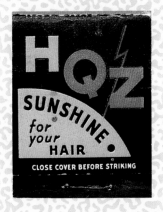

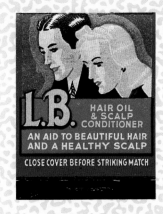

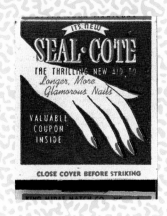

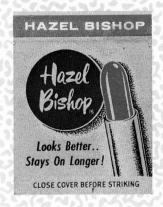

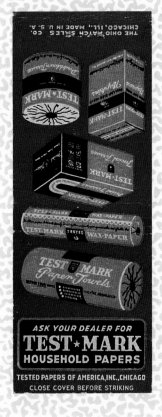

Auto Parts

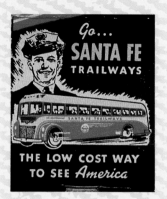

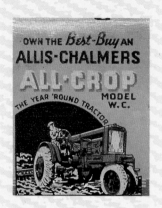

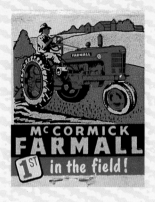

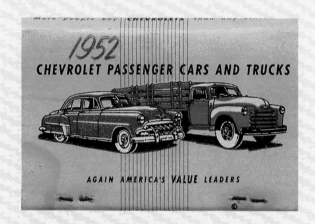

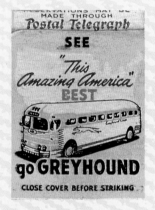

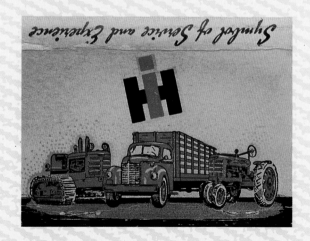

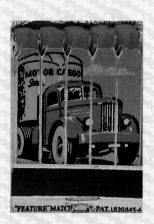

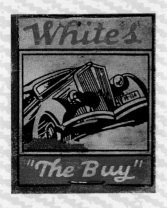

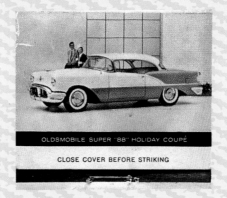

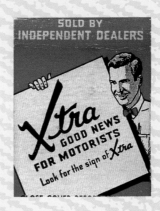

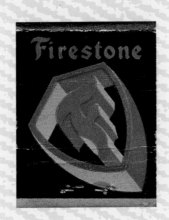

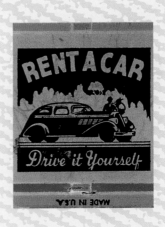

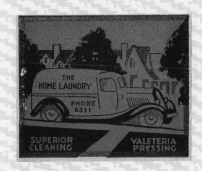

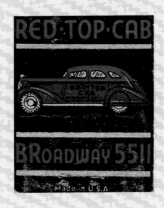

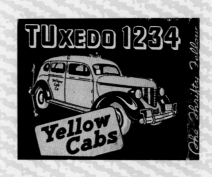

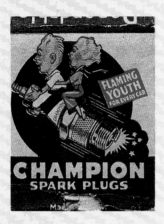

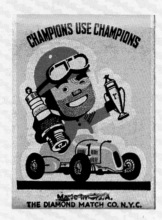

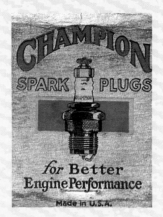

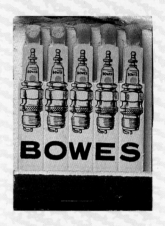

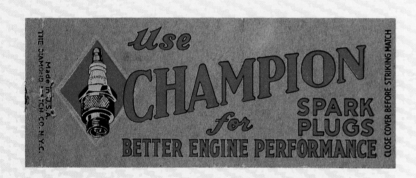

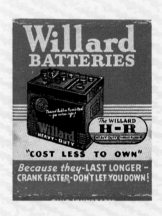

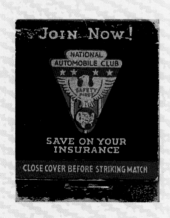

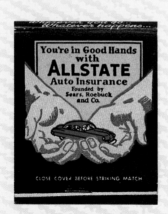

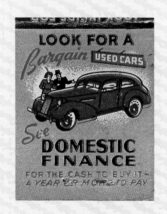

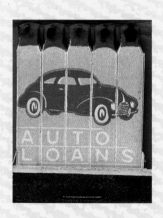

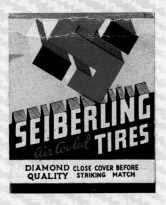

SEIBERLING TIRES
Air Cooled
DIAMOND CLOSE COVER BEFORE
QUALITY STRIKING MATCH

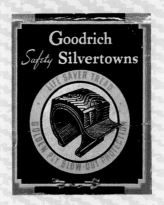

Goodrich
Safety Silvertowns
LIFE SAVER TREAD
GOLDEN PLY BLOW-OUT PROTECTION

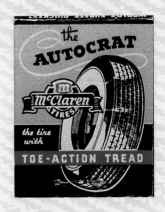

the
AUTOCRAT
McClaren
TIRES
the tire
with
TOE-ACTION TREAD

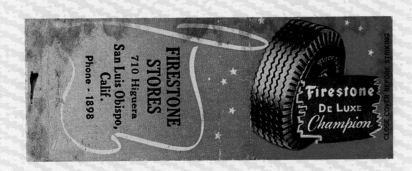

FIRESTONE STORES
710 Higuera
San Luis Obispo,
Calif.
Phone - 1898
Firestone
De Luxe
Champion
CLOSE COVER BEFORE STRIKING

Firestone
Gum Dipped TIRES
MOST MILES PER DOLLAR
CLOSE COVER BEFORE STRIKING MATCH

Smart and Thrifty!
KELLY'S ARE TOUGH!

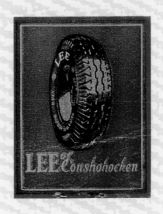

LEE
LEE of Conshohocken

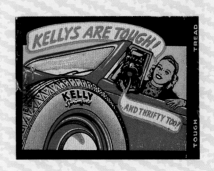

KELLYS ARE TOUGH!
TREAD
KELLY
Springfield
...AND THRIFTY TOO!
TOUGH

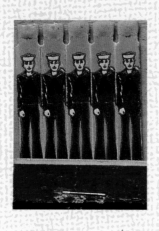

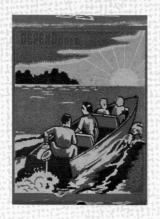

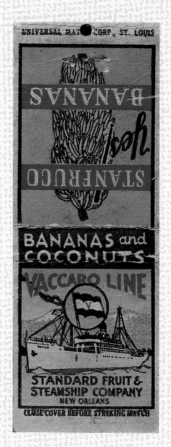

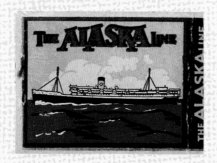

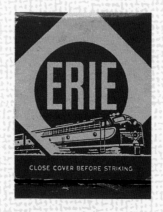

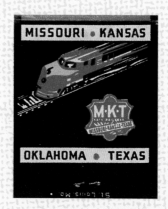

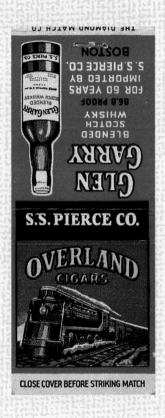
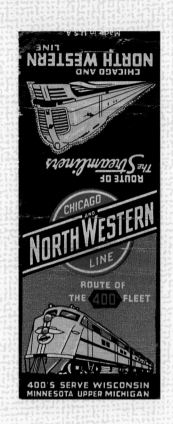
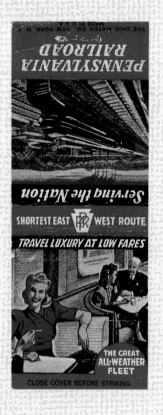

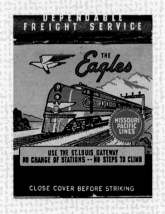
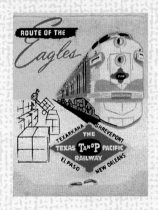

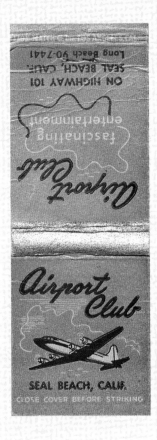

Airport Club

On Highway 101
Seal Beach, Calif.
Long Beach 90-7441

fascinating
entertainment

Airport Club

SEAL BEACH, CALIF.

CLOSE COVER BEFORE STRIKING

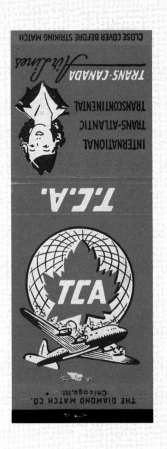

CLOSE COVER BEFORE STRIKING MATCH

TRANS-CANADA Air Lines

INTERNATIONAL
TRANS-ATLANTIC
TRANSCONTINENTAL

T.C.A.

TCA

THE DIAMOND MATCH CO. • Chicago, Ill.

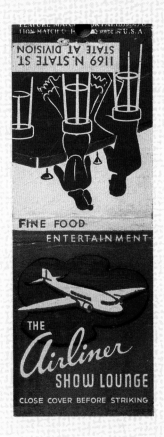

FEATURE MATCH . . . PORT PAT. 1,933,204 B
TION MATCH . . . MADE IN U.S.A.

1169 N. STATE ST.
STATE AT DIVISION

FINE FOOD

ENTERTAINMENT

THE

Airliner

SHOW LOUNGE

CLOSE COVER BEFORE STRIKING

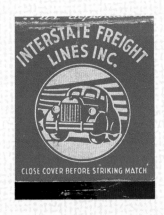

INTERSTATE FREIGHT
LINES INC.

CLOSE COVER BEFORE STRIKING MATCH

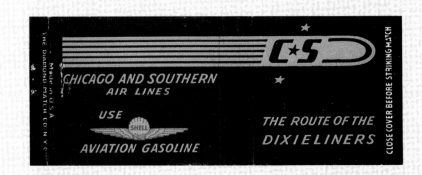

CHICAGO AND SOUTHERN
AIR LINES

USE

SHELL

AVIATION GASOLINE

THE ROUTE OF THE
DIXIELINERS

CLOSE COVER BEFORE STRIKING MATCH

MADE IN U.S.A.
THE DIAMOND MATCH CO. N.Y.C.

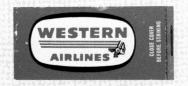

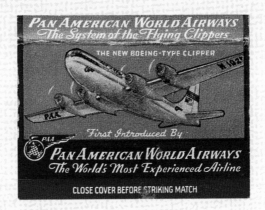

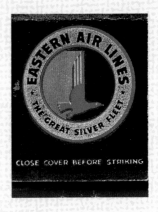

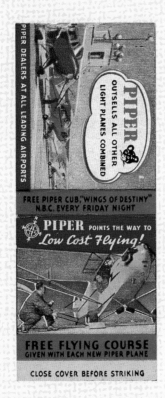

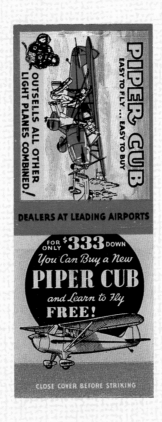

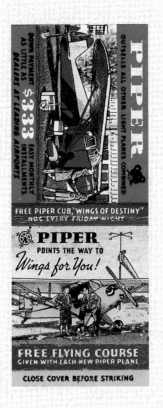

National Forests

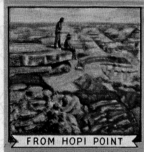

GRAND CANYON NATIONAL PARK

THE DIAMOND MATCH CO. N.Y.C.
Made in U.S.A.

Fred Harvey

Most of the stories of what people have said on catching their first glimpse of the Grand Canyon are unbelievable until, from such an outlook as HOPI POINT affords, the visitor experiences the thrill of seeing the titanic spectacle for himself.

FROM HOPI POINT
CLOSE COVER BEFORE STRIKING MATCH

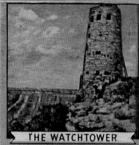

GRAND CANYON NATIONAL PARK

THE DIAMOND MATCH CO. N.Y.C.
Made in U.S.A

Fred Harvey

From its great height, THE WATCHTOWER at Desert View commands a sweeping panorama of the Painted Desert and the Kaibab National Forest, and breath-taking views of the mightiest of all spectacles - - the Grand Canyon of Arizona.

THE WATCHTOWER
CLOSE COVER BEFORE STRIKING MATCH

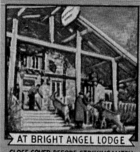

GRAND CANYON NATIONAL PARK

THE DIAMOND MATCH CO. N.Y.C.
Made in U.S.A.

Fred Harvey

Visitors to Grand Canyon National Park often see native deer browsing about the grounds of BRIGHT ANGEL LODGE. Wild deer of this species abound in the nearby Kaibab National Forest.

AT BRIGHT ANGEL LODGE
CLOSE COVER BEFORE STRIKING MATCH

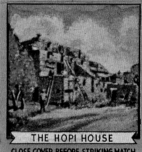

GRAND CANYON NATIONAL PARK

THE DIAMOND MATCH CO. N.Y.C.
Made in U.S.A.

Fred Harvey

Near the world-famous El Tovar Hotel is the fascinating HOPI HOUSE, authentic reproduction of an actual Hopi dwelling, with its interesting glimpses of Indian life.

THE HOPI HOUSE
CLOSE COVER BEFORE STRIKING MATCH

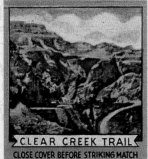

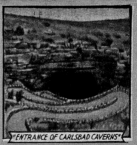

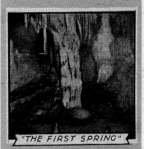

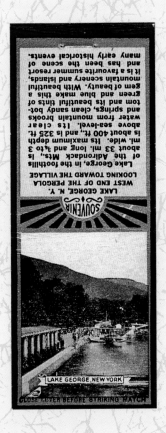
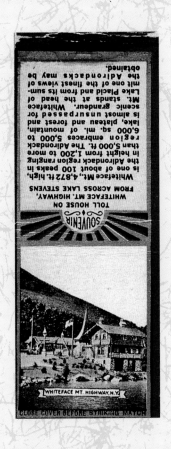
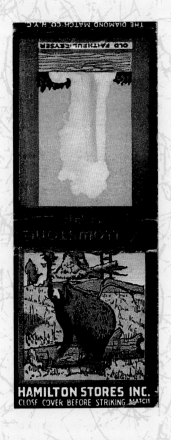
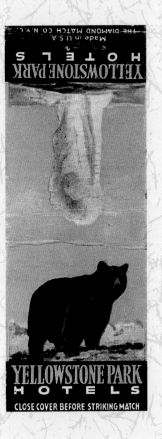

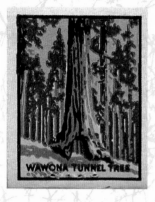

WAWONA TUNNEL TREE

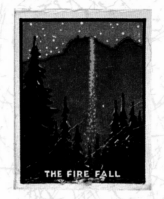

THE FIRE FALL

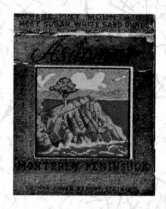

MONTEREY PENINSULA

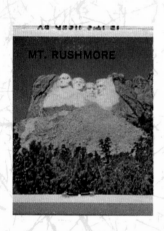

MT. RUSHMORE

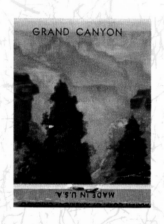

GRAND CANYON

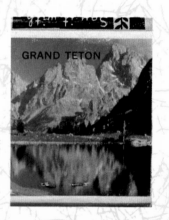

GRAND TETON

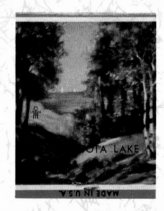

OTA LAKE

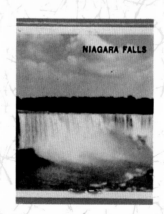

NIAGARA FALLS

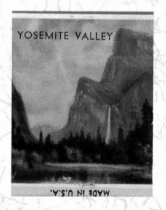

YOSEMITE VALLEY

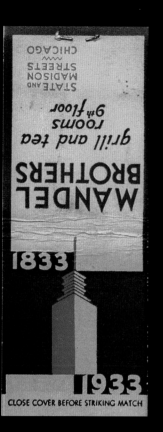

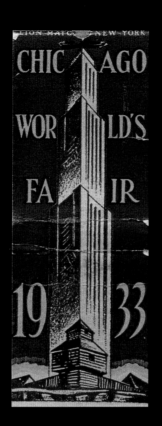

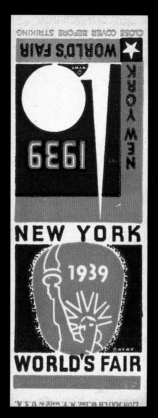

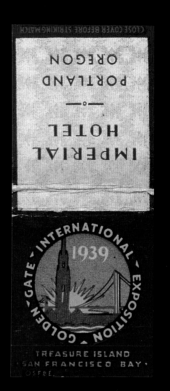

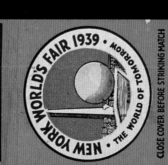

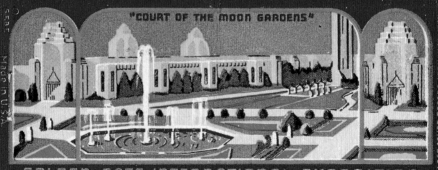

"THE GAYWAY"

·GOLDEN GATE INTERNATIONAL EXPOSITION·

·GOLDEN GATE INTERNATIONAL EXPOSITION·

"COURT OF THE MOON GARDENS"

·GOLDEN GATE INTERNATIONAL EXPOSITION·

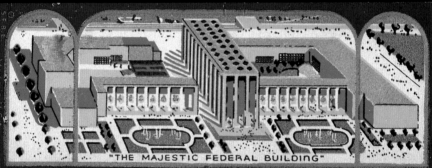

PACIFIC NATIONS

S.I.B.E. Made in U.S.A. THE DIAMOND MATCH CO. CHICO

CLOSE COVER BEFORE STRIKING MATCH

· GOLDEN GATE INTERNATIONAL EXPOSITION ·

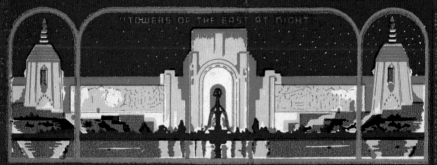

S.I.B.E. Made in U.S.A. THE DIAMOND MATCH CO. CHICO CAL.

CLOSE COVER BEFORE STRIKING MATCH

"THE MAJESTIC FEDERAL BUILDING"

· GOLDEN GATE INTERNATIONAL EXPOSITION ·

"TOWERS OF THE EAST AT NIGHT"

CLOSE COVER BEFORE STRIKING MATCH

· GOLDEN GATE INTERNATIONAL EXPOSITION ·

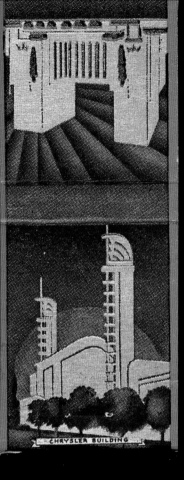

CHRYSLER BUILDING

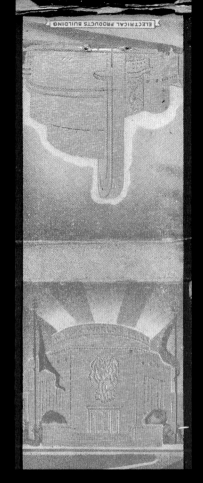

ELECTRICAL PRODUCTS BUILDING

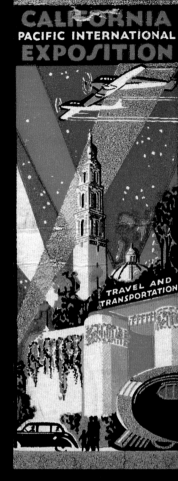

CALIFORNIA
PACIFIC INTERNATIONAL
EXPOSITION

TRAVEL AND
TRANSPORTATION

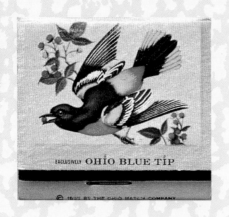

EXCLUSIVELY **OHIO BLUE TIP**

© 1955 BY THE OHIO MATCH COMPANY

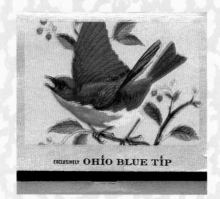

EXCLUSIVELY **OHIO BLUE TIP**

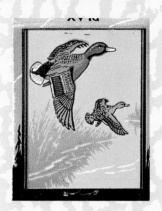

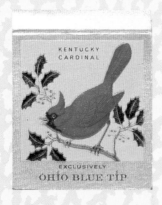

KENTUCKY
CARDINAL

EXCLUSIVELY
OHIO BLUE TIP

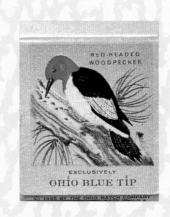

RED-HEADED
WOODPECKER

EXCLUSIVELY
OHIO BLUE TIP

© 1955 BY THE OHIO MATCH COMPANY

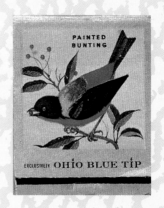

PAINTED
BUNTING

EXCLUSIVELY **OHIO BLUE TIP**

ON THE WING

QUICK ACTION

LIBERTYVILLE, ILL.

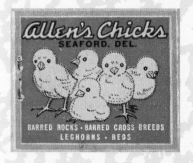

Allen's Chicks
SEAFORD, DEL.

BARRED ROCKS · BARRED CROSS BREEDS
LEGHORNS · REDS

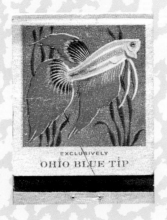

EXCLUSIVELY
OHIO BLUE TIP

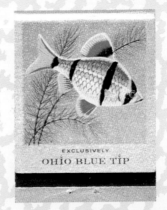

EXCLUSIVELY
OHIO BLUE TIP

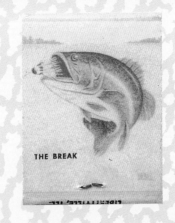

THE BREAK

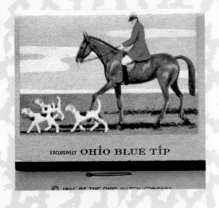

EXCLUSIVELY OHIO BLUE TIP

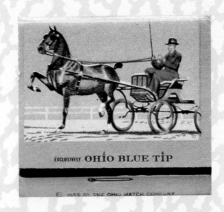

EXCLUSIVELY OHIO BLUE TIP

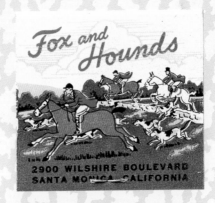

Fox and Hounds

2900 WILSHIRE BOULEVARD
SANTA MONICA, CALIFORNIA

SHEPHARD

TERRIER

BOXER

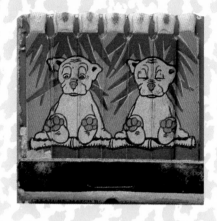

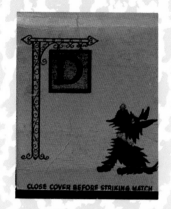

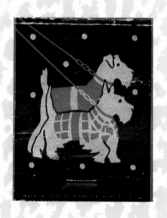

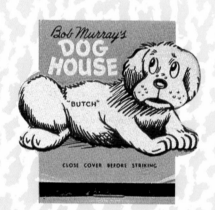

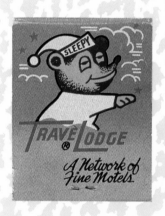

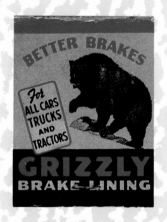

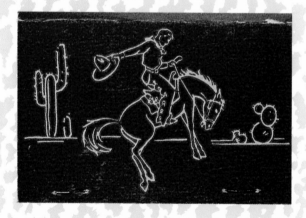

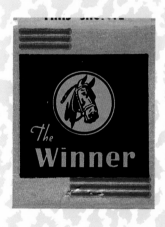

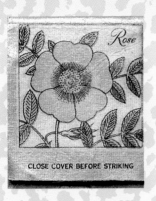

Rose

CLOSE COVER BEFORE STRIKING

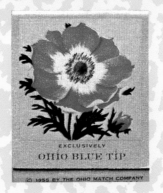

EXCLUSIVELY
OHIO BLUE TIP

© 1955 BY THE OHIO MATCH COMPANY

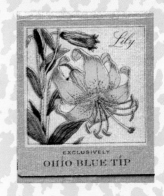

Lily

EXCLUSIVELY
OHIO BLUE TIP

Plants

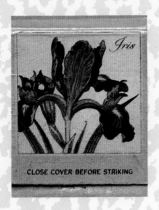

Iris

CLOSE COVER BEFORE STRIKING

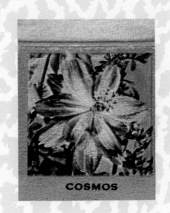

COSMOS

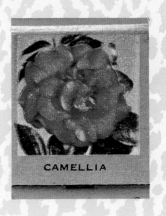

CAMELLIA

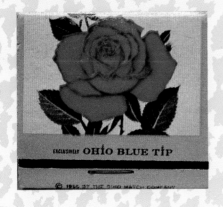

EXCLUSIVELY OHIO BLUE TIP

© 1955 BY THE OHIO MATCH COMPANY

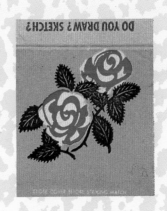

DO YOU DRAW? SKETCH?

CLOSE COVER BEFORE STRIKING MATCH

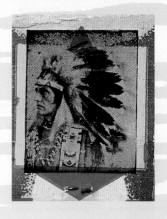

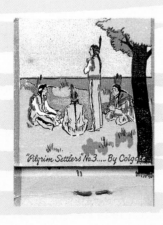

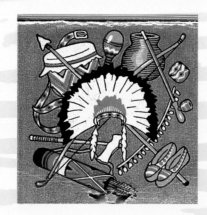

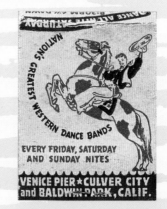

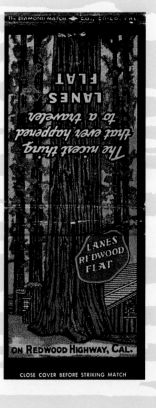

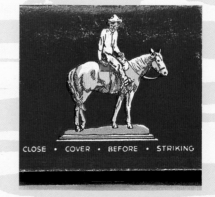

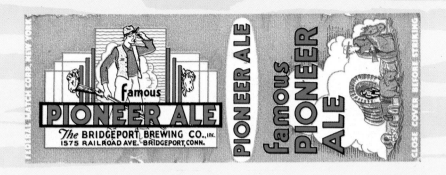

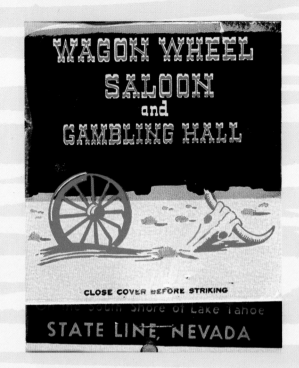

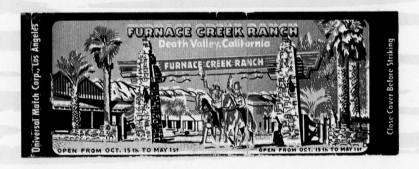

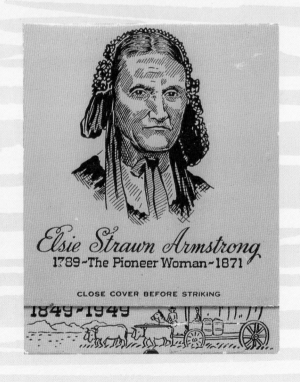

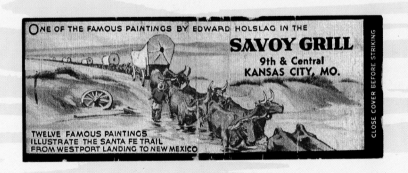

Insurance, Banks

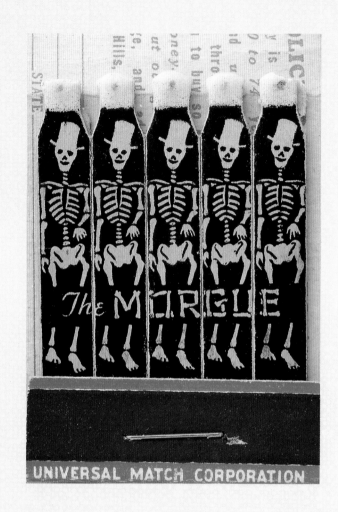

UNIVERSAL MATCH CORPORATION

The MORGUE

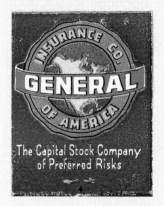

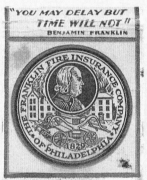

"YOU MAY DELAY BUT TIME WILL NOT"
BENJAMIN FRANKLIN

CLOSE COVER BEFORE STRIKING MATCH

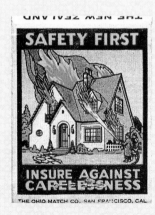

SAFETY FIRST

INSURE AGAINST CARELESSNESS

THE OHIO MATCH CO. SAN FRANCISCO, CAL.

MEMBER

DEAL WITH A Realtor

MADE IN U.S.A

ACACIA MUTUAL LIFE INSURANCE COMPANY
HOME OFFICE-WASHINGTON, D.C.

FRED T. DUNSTAN
2457 Heliotrope Dr.
Santa Ana, Calif.
PHONE 1801 W

INSURE SAFETY - CLOSE BEFORE STRIKING

THE LEWIS COMPANY, WASHINGTON, D.C.

SERVEL ELECTROLUX MADE BY SERVEL INC.

ELECTROLUX
REFRIGERATOR

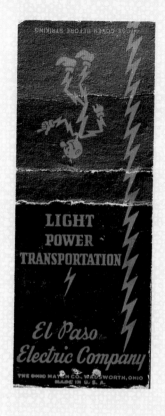

CLOSE COVER BEFORE STRIKING

LIGHT
POWER
TRANSPORTATION

El Paso Electric Company

THE OHIO MATCH CO., WADSWORTH, OHIO
MADE IN U.S.A.

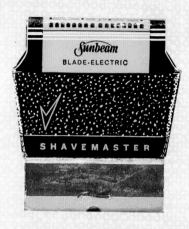

Sunbeam
BLADE-ELECTRIC

SHAVEMASTER

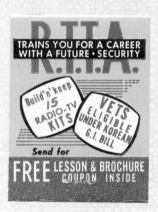

R.T.A.
TRAINS YOU FOR A CAREER
WITH A FUTURE · SECURITY

Build'n'keep
15
RADIO-TV
KITS

VETS
ELIGIBLE
UNDER KOREAN
G.I. BILL

Send for
FREE LESSON & BROCHURE
COUPON INSIDE

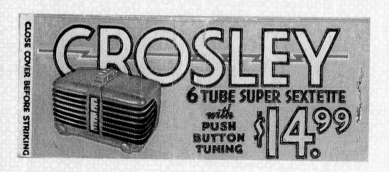

CLOSE COVER BEFORE STRIKING

CROSLEY
6 TUBE SUPER SEXTETTE
with
PUSH
BUTTON
TUNING
$14.99

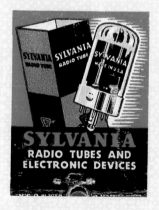

SYLVANIA
RADIO TUBE
SYLVANIA
RADIO TUBE
SYLVANIA
MADE IN USA

SYLVANIA
RADIO TUBES AND
ELECTRONIC DEVICES

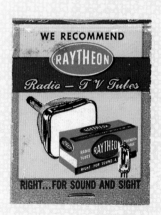

WE RECOMMEND
RAYTHEON
Radio – T V Tubes

RIGHT...FOR SOUND AND SIGHT

thers

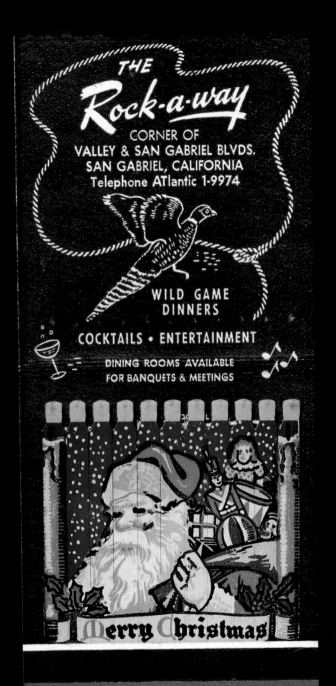

THE
Rock-a-way
CORNER OF
VALLEY & SAN GABRIEL BLVDS.
SAN GABRIEL, CALIFORNIA
Telephone ATlantic 1-9974

WILD GAME
DINNERS

COCKTAILS • ENTERTAINMENT

DINING ROOMS AVAILABLE
FOR BANQUETS & MEETINGS

Merry Christmas

The accent is on Fine Food

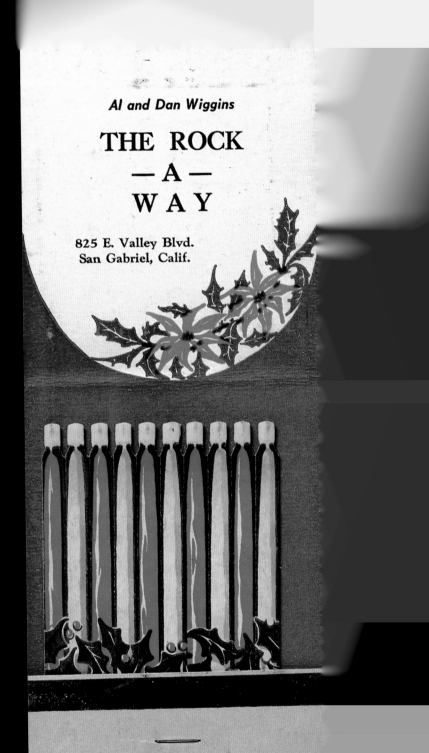

Al and Dan Wiggins

THE ROCK
— A —
WAY

825 E. Valley Blvd.
San Gabriel, Calif.

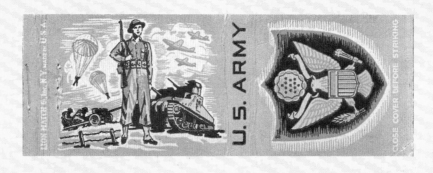

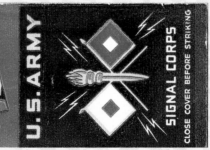

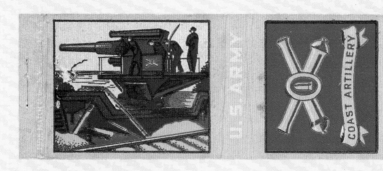

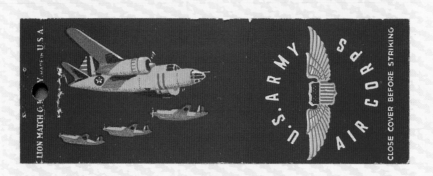

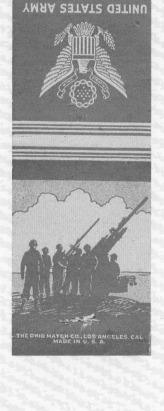

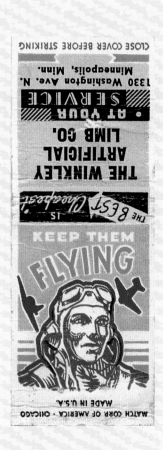

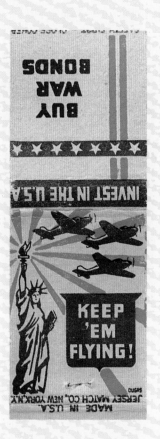

115

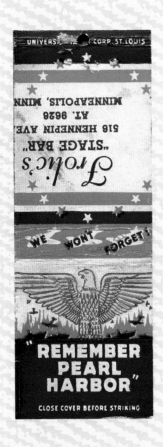

UNIVERSAL MATCH CORP. ST. LOUIS

Frolic's
"STAGE BAR"
516 HENNEPIN AVE.
AT. 9626
MINNEAPOLIS, MINN.

WE WONT FORGET!

"REMEMBER
PEARL
HARBOR"

CLOSE COVER BEFORE STRIKING

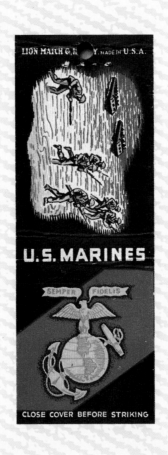

LION MATCH CO., N. Y. MADE IN U.S.A.

U.S. MARINES

SEMPER FIDELIS

CLOSE COVER BEFORE STRIKING

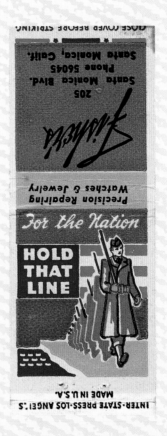

CLOSE COVER BEFORE STRIKING

205
Santa Monica Blvd.
Phone 56045
Santa Monica, Calif.

Fisher

Precision Repairing
Watches & Jewelry

For the Nation

HOLD
THAT
LINE

INTER-STATE PRESS-LOS ANGEL'S.
MADE IN U.S.A.

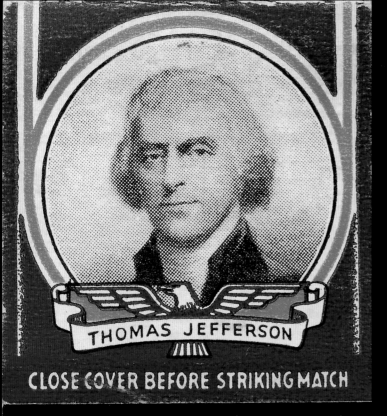

THOMAS JEFFERSON

CLOSE COVER BEFORE STRIKING MATCH

JOHN ADAMS

CLOSE COVER BEFORE STRIKING MATCH

CHESTER ALAN ARTHUR

CLOSE COVER BEFORE STRIKING MATCH

WILLIAM McKINLEY

CLOSE COVER BEFORE STRIKING MATCH

WILLIAM TAFT

CLOSE COVER BEFORE STRIKING MATCH

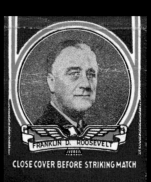

FRANKLIN D. ROOSEVELT

CLOSE COVER BEFORE STRIKING MATCH

Portrait

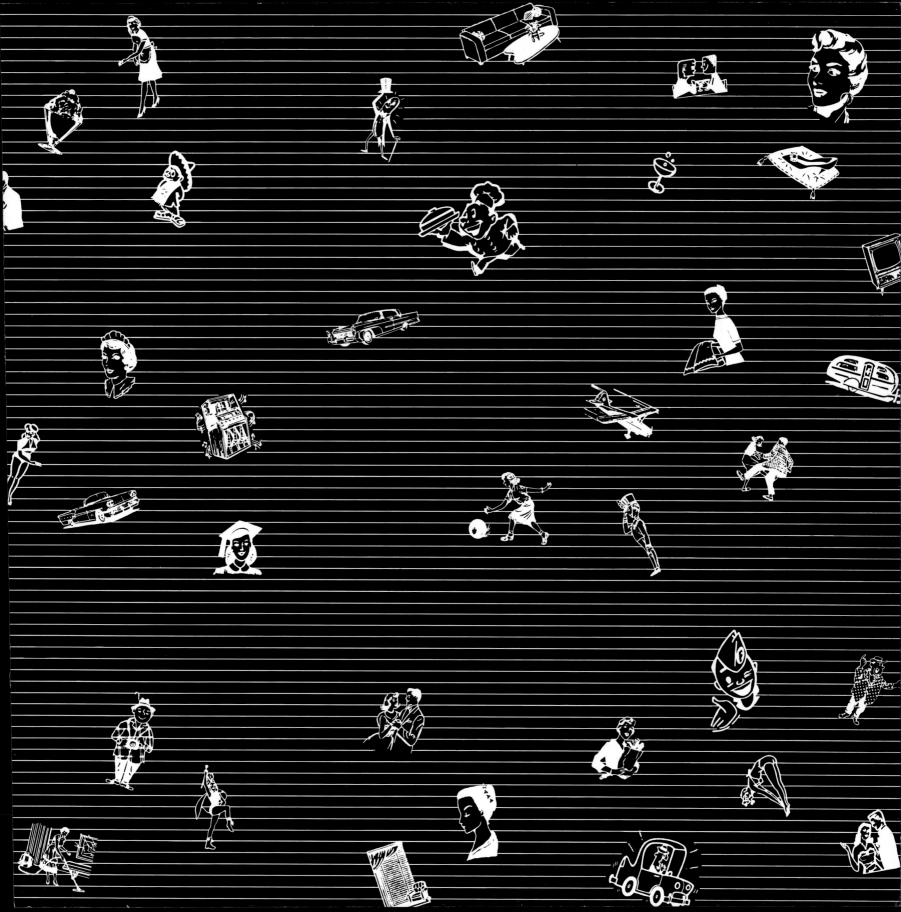